for
David,
Be Dareful
out there!
Jer Collins

DrAWn

THE ART OF ASCENT

JEREMY COLLINS

MOUNTAINEERS
BOOKS

MOUNTAINEERS BOOKS

Mountaineers Books is the publishing division of The Mountaineers, an organization founded in 1906 and dedicated to the exploration, preservation, and enjoyment of outdoor and wilderness areas.

1001 SW Klickitat Way, Suite 201, Seattle, WA 98134
800.553.4453, www.mountaineersbooks.org

Printed in China
Distributed in the United Kingdom by Cordee, www.cordee.co.uk

18 17 16 15 1 2 3 4 5

Copy editor: Sherri Schultz
Book design, layout, and art: Jeremy Collins
Production: Jen Grable
All photographs by James Q Martin, www.jamesqmartin.com, except the following: page 14, by Mikey Schaefer, and pages 87 and 88, courtesy of José Miranda

Library of Congress Cataloging-in-Publication Data on file

ISBN: 978-1-59485-958-8

Dedicated to Tricia, who lets me go

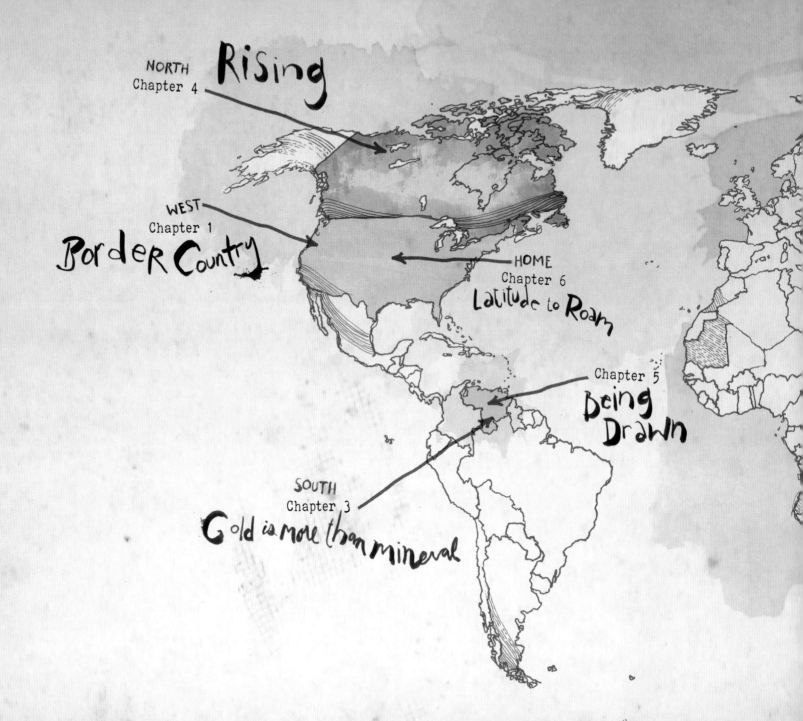

NORTH
Chapter 4
Rising

WEST
Chapter 1
Border Country

HOME
Chapter 6
Latitude to Roam

Chapter 5
being
Drawn

SOUTH
Chapter 3
Gold is more than mineral

N

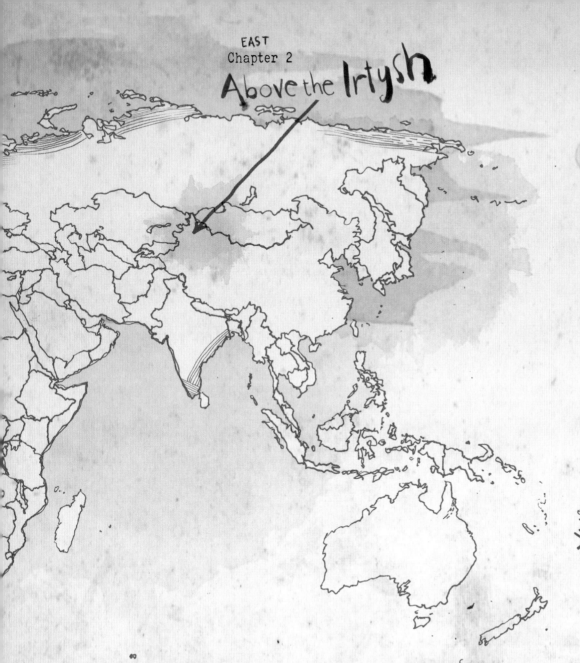

DRAWn
THE ART OF ASCENT

"You cannot stay on the summit forever; you have to come down again. So why bother in the first place? Just this: What is above knows what is below, but what is below does not know what is above. One climbs, one sees. One descends, one sees no longer, but one has seen. There is an art of conducting oneself in the lower regions by the memory of what one saw higher up. When one can no longer see, one can at least still know."

— René Daumal, Mount Analogue

PROLOGUE

What does it mean to see?

Shapes and shadows? Lines and color? Or does it mean more?

People told us that once we were married and had kids, our adventures would be over. But I didn't see it that way. I felt I could exist in a "love paradox," where adventure and family both got 100 percent of me. We're told it's good to get comfortable, settle down, buy a bigger house and a better car, and start stockpiling the 401(k). But that's not necessarily right for everyone. It wasn't right for me.

AND it's not right for Jonny.

Jonny Copp is one of my closest friends, and a leader in the American climbing community. Our relationship blurs the line between friendship and mentorship. He keeps it simple: a simple old pickup truck, a simple apartment, a simple existence. His climbs, though, are far from simple—complex and dangerous routes in the mountains, from the Karakorum to South America and back home again. His perspective on what is real danger and perceived danger affects his daily life; he exudes this air of calm and comfort that I find alluring.

I share Jonny's obsession with adventures in the mountains. The farther away from my desk, the better. At 32 years old, however, somewhere between college and mortgage, I had lost sight of what I was capable of; I was ready, and needed, to go bigger, and Jonny understood. On a climb together in southwestern Colorado, I told him about a vision I had: to go in the four cardinal directions from home—West, East, South, North—to climb something spectacular and fill my sketchbooks with the experiences, the stories, the visions.
I wanted to climb routes that no one had before and truly see what I could do.

Jonny slapped my back and said, When do we get started?
I stopped dreaming and started planning.

CHAPTER 1:
WEST
Border Country

"Through a meadow opening in the pine woods I see snowy peaks about the headwaters of the Merced above Yosemite. How near they seem and how clear their outlines on the blue air, or rather in the blue air; for they seem to be saturated with it. How consuming strong the invitation they extend! Shall I be allowed to go to them? Night and day I'll pray that I may, but it seems too good to be true."

John Muir,
My First Summer in the Sierra

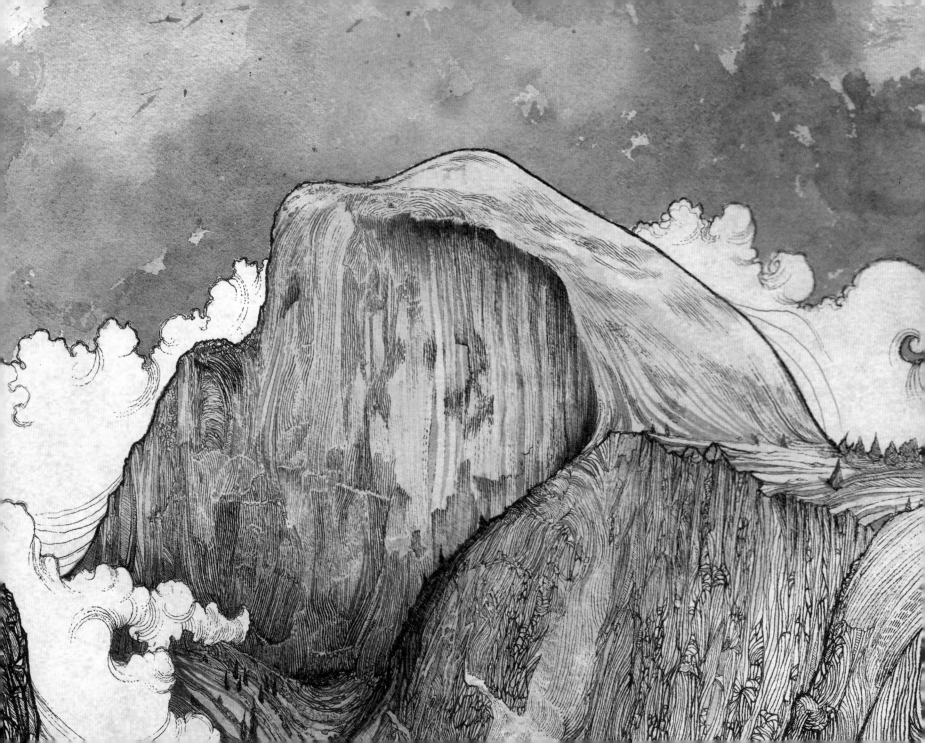

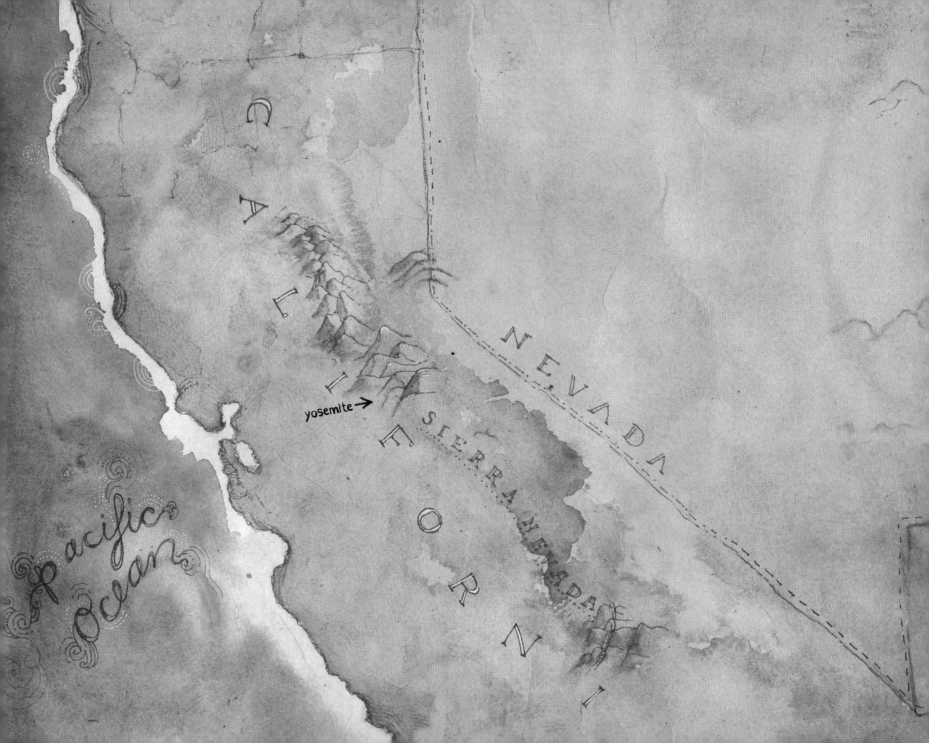

I returned home to my domestic reality after a climbing trip to Patagonia.

I took out the trash on Monday morning.

I mowed the lawn, I checked the mail.

My wife, Tricia, tolerated my spontaneous couch-presented slideshows and stories about the recent journey, even though she had heard them all before. I watched cartoons with my son, Zion, went for long trail runs, caught up on work, and climbed local limestone.

Then the phone rang, and with that came the start of my Jonny - approved vision...

On the phone

was Mikey Schaefer, a climber and adventure photographer who lives half the year in a van and the other half in a tent. He had just moved from his tent back into the van and wondered if I might like to meet him in Yosemite National Park in California for a potential new route he had found on Middle Cathedral.

When Mikey called, my idea of going in the four directions was still just an idea, whispered to Jonny and scribbled into a sketchbook in a garbled font. It had not grown the proverbial legs, or even metaphorical wings.

I write down LoTS of Ideas. Many are USeless-Vile-Troll DUNG ideas. Some are not-worth-the-paper-they-are-written-on ideas.

No matter how
WRETCHED
and pointless,
OUR ideas
are the most
TRUE things
about us. Whether
we have an idea
to move the couch from
one side of the Room
to the OtheR,
CHANGE PANTS,
CHANGE JOBS, or
CHANGE THE
WORLD, ideas matter.

CLOUDS REST

HALF DOME

MT WATKINS

NORTH DOME

VERNAL FALLS

WASHINGTON COLUMN

GLACIER POINT

SENTINAL

YOSEMITE FALLS

EL CAPITAN

MIDDLE HIGHER

CATHEDRAL SPIRES

MERCED RIVER

BRIDALVEIL FALLS

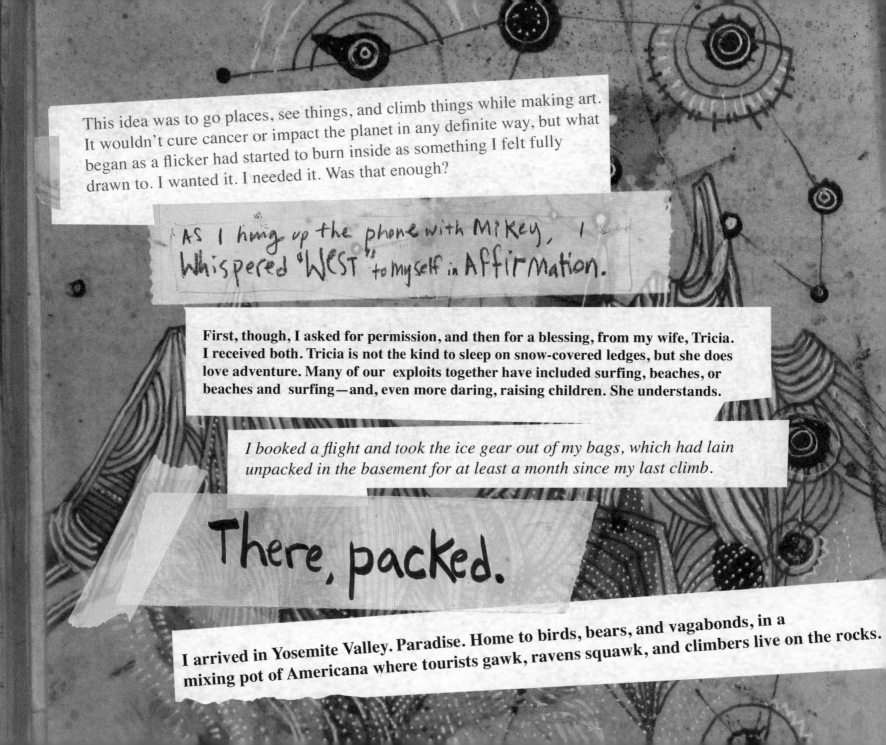

This idea was to go places, see things, and climb things while making art. It wouldn't cure cancer or impact the planet in any definite way, but what began as a flicker had started to burn inside as something I felt fully drawn to. I wanted it. I needed it. Was that enough?

AS I hung up the phone with Mikey, I whispered "WEST" to myself in Affirmation.

First, though, I asked for permission, and then for a blessing, from my wife, Tricia. I received both. Tricia is not the kind to sleep on snow-covered ledges, but she does love adventure. Many of our exploits together have included surfing, beaches, or beaches and surfing—and, even more daring, raising children. She understands.

I booked a flight and took the ice gear out of my bags, which had lain unpacked in the basement for at least a month since my last climb.

There, packed.

I arrived in Yosemite Valley. Paradise. Home to birds, bears, and vagabonds, in a mixing pot of Americana where tourists gawk, ravens squawk, and climbers live on the rocks.

North of the valley, in Tuolumne Meadows in the summer of 1869, a 31-year-old sheepherder named John Muir completed what is known as the first technical ascent of a peak in the area—that is, the hardest way to the top. Alone, he climbed Cathedral Peak without a rope, passing a *"30 foot tall block, steep on all sides."* Most climbers to this day still use ropes there.

Muir's lifelong love affair with Yosemite had begun. In his book *My First Summer in the Sierra*, he describes the Cathedral with reverence:

"No Wonder the hills and groves were God's first temples, and the more they are cut down and hewn into Cathedrals and Churches, the farther off and dimmer seems the Lord himself. The same may be said of Stone temples. Yonder, to the Eastward of our camp grove, stands one of Natures Cathedrals, hewn from the living Rock, almost conventional in form, about two-thousand feet high, nobly adorned with spires and pinnacles, thrilling under floods of sunshine as if Alive like a grove-temple, and well named — 'Cathedral Peak'."

In the middle of the valley rises a series of jagged Summits aptly named Cathedral Spires, similar to MUIR'S revered peak and defined as HIGHER, Middle, and LOWER CATHEDRALS

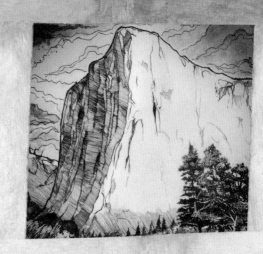

The higher and lower summits were reached in 1934 by a tenacious team from the Bay Area Sierra Club led by Jules Eichorn. These were the first technical climbs in the valley utilizing modern techniques such as rope and pitons. (To afford the pitons, Eichorn worked extra hours for his piano teacher—an up-and-coming photographer by the name of Ansel Adams.) Middle Cathedral didn't host its first summit visitor until 20 years later, when Warren Harding climbed it four years before climbing El Capitan, directly across the valley.

It Was here that Mikey had Spied a NEWLINE—up Middle Cathedral's golder northwestern face, tucked in a craggy drainage between it and neighboring lower Cathedral.

Face to face with the king of all rock walls, El Capitan, Mikey called Middle Cathedral a "2,000–foot-tall redheaded stepchild" in comparison.

But it was WEST and it was Unclimbed rock.

I was hooked.

During three days of rain, we prepped our gear and took naps.
Between coffee breaks we read books while curled up like wet dogs in Mikey's van.
The rain clung to the windshield, forming an abstract, pixelated visage of Half Dome high above us.

Tourists scurried between restaurants and the grocery store and the gift shop, while fattened squirrels darted from their notches for a nibble of fries or ice cream. A CROW hopped across the street at an intersection, knowing that _now_ was _its_ turn to walk. The valley hummed with life, as it always has in one form or another.

middle cathedral

Despite reading everything from John Muir to John LONG, I didn't grow up wanting to be a writer or a climber. I grew up wanting to be an Indian. I crept through the woods with my brothers, collecting sticks, making bows and arrows for our battles, and investigating the various mysteries of nature.

Admittedly, I would have made a horrible woodsman. I have never wanted to hunt, and I have the attention span of a hummingbird, so tracking animals or enemies wouldn't have worked out so well. Rather, I was drawn to the rogue romance of living life on nature's schedule—following the stars and existing with an awareness of our connection to all living things.

Climbing mountains gives me the connection to myself and the planet I have always felt I needed.

The rain stopped, and we put our harnesses on.

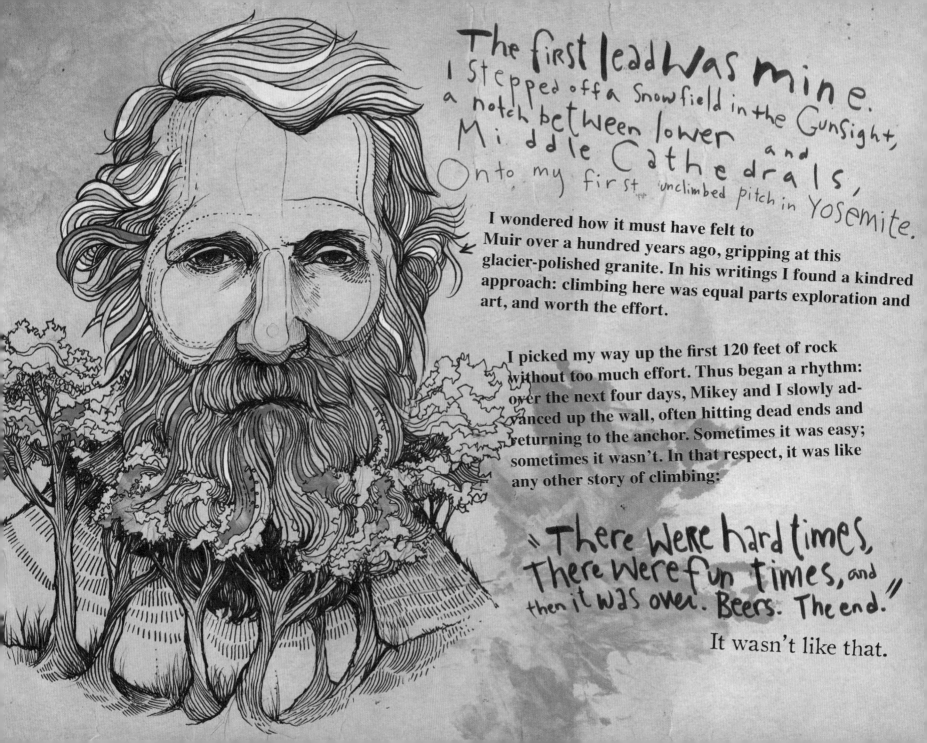

The first lead was mine. I stepped off a snowfield in the Gunsight, a notch between lower and Middle Cathedrals, onto my first unclimbed pitch in Yosemite.

I wondered how it must have felt to Muir over a hundred years ago, gripping at this glacier-polished granite. In his writings I found a kindred approach: climbing here was equal parts exploration and art, and worth the effort.

I picked my way up the first 120 feet of rock without too much effort. Thus began a rhythm: over the next four days, Mikey and I slowly advanced up the wall, often hitting dead ends and returning to the anchor. Sometimes it was easy; sometimes it wasn't. In that respect, it was like any other story of climbing:

"There were hard times, there were fun times, and then it was over. Beers. The end."

It wasn't like that.

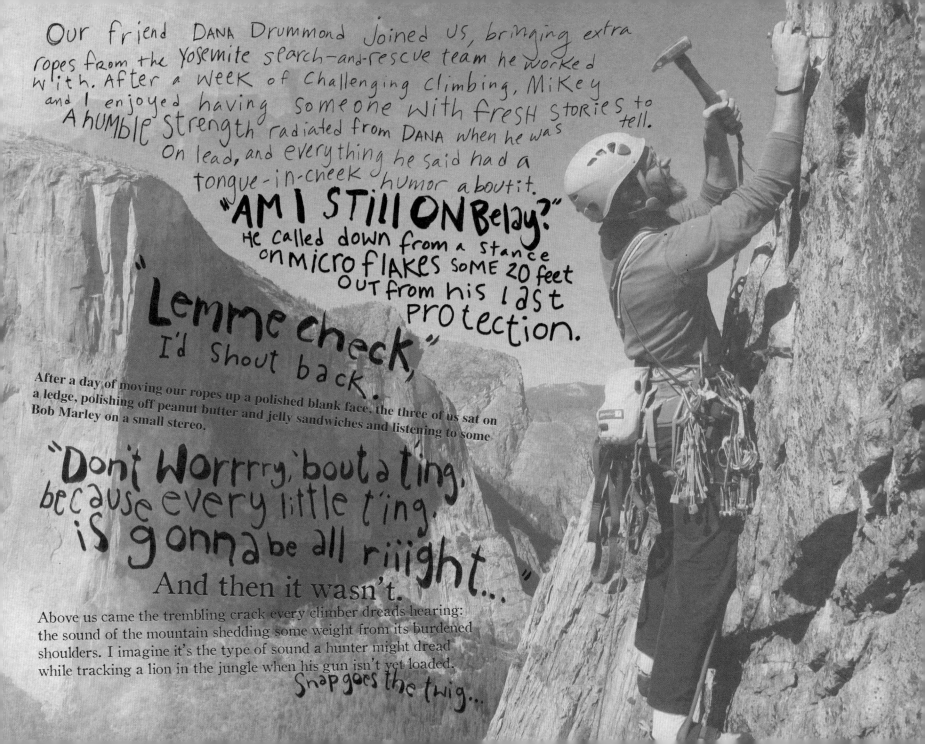

Our friend DANA Drummond joined us, bringing extra ropes from the Yosemite search-and-rescue team he worked with. After a week of challenging climbing, Mikey and I enjoyed having someone with fresh stories to tell. A humble strength radiated from DANA when he was on lead, and everything he said had a tongue-in-cheek humor about it.

"AM I STILL ON Belay?" He called down from a stance on micro FLAKES SOME 20 feet OUT from his last protection.

"Lemme check," I'd shout back.

After a day of moving our ropes up a polished blank face, the three of us sat on a ledge, polishing off peanut butter and jelly sandwiches and listening to some Bob Marley on a small stereo.

"Don't Worrrry 'bout a ting. because every little t'ing. is gonna be all riiight..."

And then it wasn't.

Above us came the trembling crack every climber dreads hearing: the sound of the mountain shedding some weight from its burdened shoulders. I imagine it's the type of sound a hunter might dread while tracking a lion in the jungle when his gun isn't yet loaded.

Snap goes the twig...

Yosemite is famous for its dramatic rockfalls — immense slabs of rock that release from the faces unannounced and without warning. Here we were, pasted to a slab some 800 feet off the ground, like window washers beneath a massive ornate stone gargoyle, and the gargoyle had taken flight. We leapt into a pile, covering our heads with our hands. Our helmets were hanging from an anchor for our siesta on the ledge.

The sound grew like a freight train that had driven off the cliff's edge and was gaining momentum downward, blowing its horn down its newfound vertical track. I caught a glimpse of Mikey's eyes and saw a black, heavy seriousness. We gripped each other around the shoulders, and Bob Marley wailed on.

AND THEN, Kaboom, The falling train of granite met the wall in a spectacular mass explosion.

My eardrums reverberated with the connection and we all froze, braced for impact in a tangle of limbs and gear. The rockfall had missed us entirely.

Mikey reached over without comment and turned off the music.

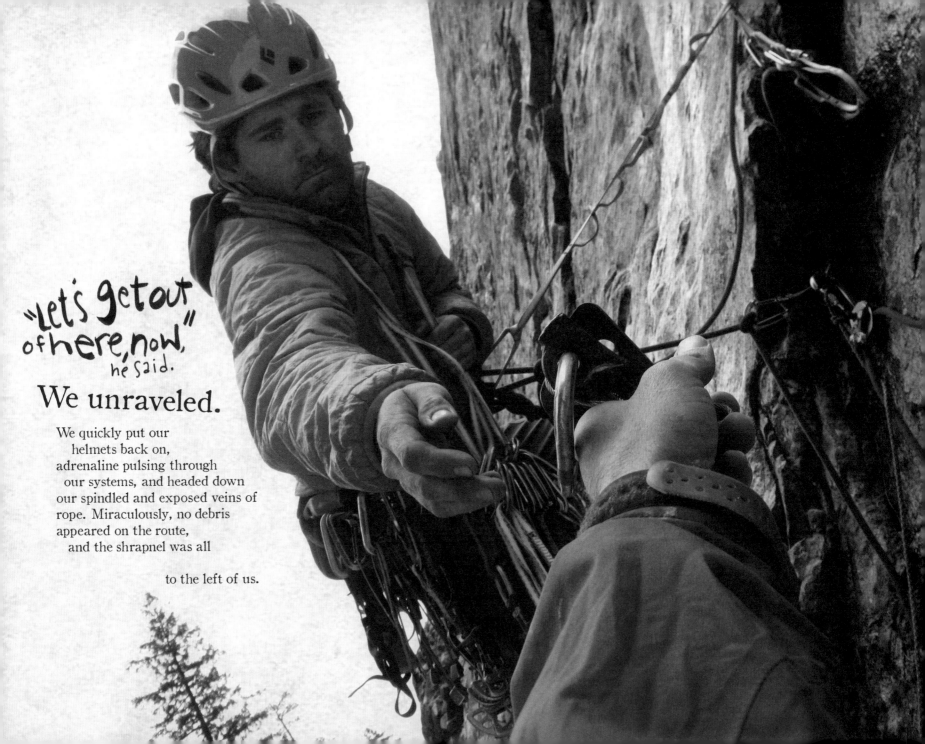

"Let's get out of here, now," he said.

We unraveled.

We quickly put our helmets back on, adrenaline pulsing through our systems, and headed down our spindled and exposed veins of rope. Miraculously, no debris appeared on the route, and the shrapnel was all

to the left of us.

The rappelling was pure stress.

The farther down we descended, the lower the angle, which kicked us out and further exposed us to whatever fragments might still be dangling above us on the headwall like gigantic Christmas ornaments. Each pull of the rope was accompanied by a dark cloud of paranoia. We got off the wall in the last purple glimmer of light, then ran through the darkened forest to the van as the adrenaline subsided into a dull, reverberating hum of reflection.

In the darkness of the forest, after some silence, I admitted, "That was terrifying." Dana confirmed with "I know, I almost dropped the jelly."

Unfortunately, this near-catastrophe marked the end of this part of the journey. All of us had to be in other places soon: Dana back home to Alaska, Mikey to a photo shoot overseas, and me back to my desk, deadlines, and family. Scattering to the winds, we made vague promises to get back to our route someday.

Was West a bust?

Maybe this just wasn't the West story I was looking for.

But I stayed committed to my intent to let the story tell itself and not rush it.

Fast-forward a couple months.

It was a dark summer night. I had been in bed for hours. The phone rang. My heart dropped.

It was 3:30 in the morning, and I didn't want to answer the call. I knew what it was. Like many others, I had been diligently watching the online feed of news from China about missing climbers on Mount Edgar. I knew all three of the men, but one of them was Jonny Copp. My friend. My mentor.

It was Renan Ozturk on the phone, a climber who fits the same description as Jonny—friend, mentor, artist. Renan has a quiet, Zen-like demeanor, often leaving you second-guessing what is on his mind as he carefully and methodically chews on what he's about to say. At six-foot-four, he often tries to hide in a room, steering toward the back and the shadows, his hands buried in his pockets. When he speaks, I listen.

"Hey man, what's up?" I asked with feigned ignorance.

"I wanted you to know first, Jer. They found their bodies."

I respected Renan so much in that moment. We talked for a minute, then said good night. I wept.

JONNY WASN'T ALONE WHEN HE DIED IN CHINA.

Jonny and I had last climbed together in the Black Canyon, in Colorado, where I had told him about my vision to go in the four directions. With a snowstorm threatening, we chose to continue up the route.

It turned into one of the greatest first ascents either of us had done: 1,200 feet of slick, gneiss granite riddled with steep cracks. We climbed it casually and quickly with no fixed lines or fixed gear, from sunup to sundown.

This was the kind of climb you dream of when you leave the ground. Like that climb, everything felt easy with Jonny. Even friendship.

Micah Dash and cameraman Wade Johnson were buried in the avalanche as well.

I waited till morning and called Mikey, whose relationship with Micah paralleled mine with Jonny.

They had been on enough adventures together to cross that line from friendship into brotherhood.

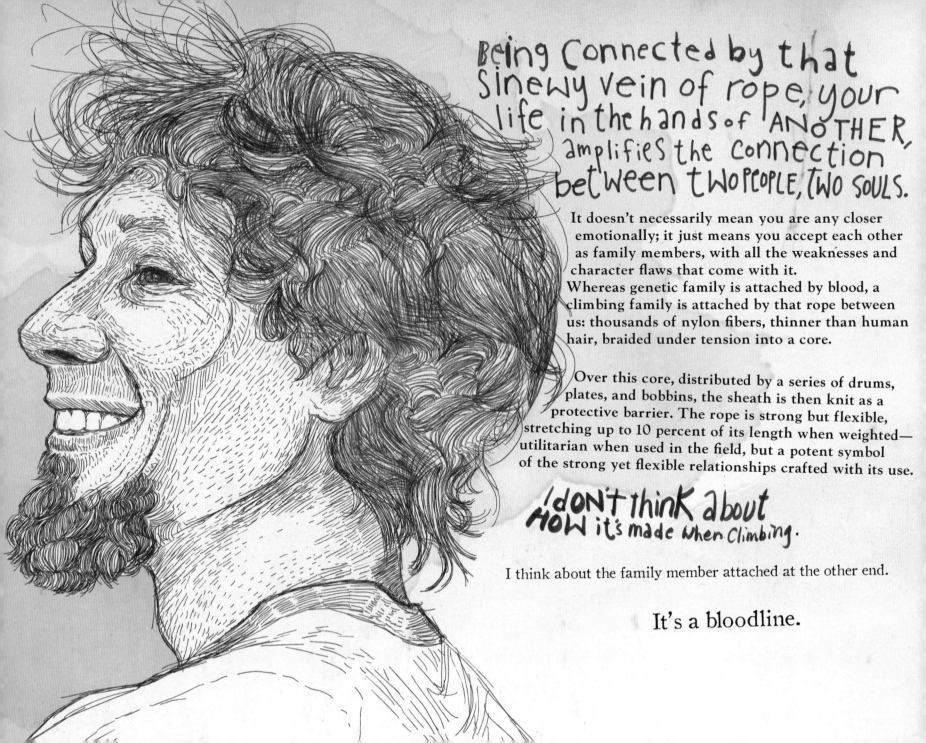

Being connected by that sinewy vein of rope, your life in the hands of ANOTHER, amplifies the connection between TWO PEOPLE, TWO SOULS.

It doesn't necessarily mean you are any closer emotionally; it just means you accept each other as family members, with all the weaknesses and character flaws that come with it.

Whereas genetic family is attached by blood, a climbing family is attached by that rope between us: thousands of nylon fibers, thinner than human hair, braided under tension into a core.

Over this core, distributed by a series of drums, plates, and bobbins, the sheath is then knit as a protective barrier. The rope is strong but flexible, stretching up to 10 percent of its length when weighted—utilitarian when used in the field, but a potent symbol of the strong yet flexible relationships crafted with its use.

I don't think about HOW it's made when climbing.

I think about the family member attached at the other end.

It's a bloodline.

Mikey and I had a short and solemn discussion with few words. We committed to return to Middle Cathedral, to finish the route we had started together, as a way to honor the memory of our fallen friends.

Mikey and Dana returned in October. I arrived in early November. Between the three of us, the route was sent all free.*

BORDER COUNTRY

On the high golden headwall, the hiss of the valley was a symphony beneath us: water plus wind orchestrated the soundtrack, with the cries of peregrine falcons like an occasional flute solo. At 2,000 feet above the valley, I reached the high point of our route and pulled a small parcel, about the size of a muffin, from my jacket.

Inside was Jonny.

Yosemite is a captivating place for me, and it was for Jonny too. His mother, Phyllis, had sent me a portion of his ashes in a colorful woven bag—perhaps one of the greatest gifts anyone had ever given me.

*sent all free: Climbed using only your hands and feet for movement, not standing in stirrups or hanging on gear. The rope and gear is only there to catch a potential fall.

Phyllis and I had never met in person, only talked on the phone in fits of tears and laughter, telling stories about Jonny. This made it hurt less.

I'm no mystic, and I don't think a person literally inhabits a place where their ashes are dropped. In a place like YOSEMITE, I'm sure there have been a thousand ceremonies like mine, starting WAY BACK with those NATIVE tribes.

But I do believe in the cathartic release for the ONE performing the ritual.

Hanging from my anchor on the side of Middle Cathedral, I unraveled the parcel and took a pinch of the soft, fibrous powder. I immediately began to cry as I felt the rush of awareness of Jonny's death, the moments of fear and decision as the rumble of snow came down the mountain to meet him and his partners like a herd of wild bulls.

I wondered what went through his mind.

In fact, Jonny gave us a hint of what was on his mind with his last poem—

prophetically, strangely, written the night before his death.

BORDER COUNTRY

HERE IT COMES
TO TAKE ME DOWN
TAKIN ME DOWN WITH A
THUNDERIN' SOUND

HERE SHE COMES
WITH ARMS SPREAD WIDE
~~CALLING~~ ME BACK FROM
BORDER COUNTRY.
∞

INCH BY INCH
STEP BY STEP
SHADOWS ARE RUNNIN IN
BOTH DIRECTIONS

COWERIN DOWN FROM
THE ECHOING SOUNDS
BRINGIN' US FACE TO ~~FACE~~

∞

TIGHTEN ~~YOUR~~ MY BOOTS
MAKE A RUN
TURN TO SEE THAT

MY ~~YOUR~~ THOUGHTS UNTIED

STANDING STILL IN THE
BLAZING SUN
NOWHERE TO HIDE IN
BORDER COUNTRY.
∞

GRABBIN' AT THE EARTH
HOLDING ON TIGHT
WISHIN FOR ~~YOUR~~ MY MOMMA
AND ~~YOUR~~ MY SWEETHEARTS
DELIGHT

PULL-OUT-A PENNYWHISTLE
LET THE OLD MAN DANCE
BUYING ~~YOUR~~ MY TICKET
OUTTA' BORDER COUNTRY

As the Sun Set in a flaming orange and pink, Jonny's ashes flew over the valley.

Mikey and I decided to name the route Border Country, after Jonny's poem. Before I left for Yosemite, at the airport, Tricia had given me a birthday gift—she announced we were pregnant again.

Life is a gift, whether ending or beginning.

The fire that had begun flickering in me months ago for the four directions was now fully ablaze, and at the same time, home and family were growing in complexity. I knew I would continue this journey and bring Jonny's ashes with me to places he'd never been—a difficult task given his track record of adventurous routes around the globe.

But I also knew that with each direction, Tricia would come "with arms spread wide, calling me back," offering protection.

offering home.

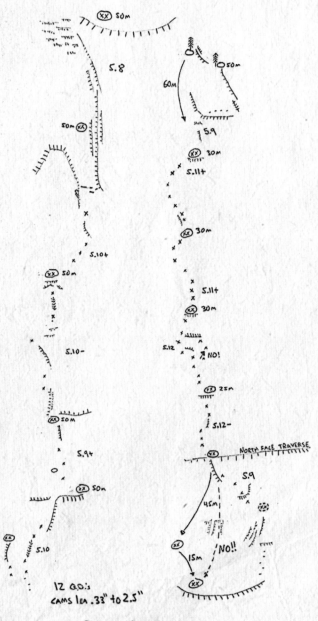

Border Country 5.12c

I rappelled back down the wall, then tightened my boots and made a run.

CHAPTER 2:
EAST
Above the Irtysh

"So many people live within unhappy circumstances and yet will not take the initiative to change their situation because they are conditioned to a life of security, conformity, and conservatism, all of which may appear to give one peace of mind, but in reality nothing is more dangerous to the adventurous spirit within a man than a secure future. The very basic core of a man's living spirit is his passion for adventure. The joy of life comes from our encounters with new experiences, and hence there is no greater joy than to have an endlessly changing horizon, for each day to have a new and different sun."

Jon Krakauer,
Into the Wild

A year later, I headed to China. Jonny came with me.

I shared the adventure with six friends:

Tommy and Becca Caldwell Hayden Kennedy Corey and Marina Rich and Mark Jenkins

My climbing partner was Mark, a writer who makes a living getting arrested and writing about it. He has been to over 100 countries and has been arrested in six. You either love him or hate him, and he seems quite proficient in forcing your opinion in either direction. At home, Mark and his wife have two daughters, so he understands the paradox of home life versus dream chasing. He is also old enough to be my dad—and in better shape than me. **We make a good team.**

Mark and I both heard about this spot on the other side of the planet in the same way: the internet. Bloggers and other climbing forums rumored that there was this canyon in a national geological preserve in northern Xinjiang, China, that had hundreds of unclimbed granite peaks....

The Keketuohai valley is largely unknown to Westerners. Located on China's remote borders with Mongolia and Kyrgyzstan, it holds ancient, pristine granite walls rising from the Irtysh River, which flows darkly through its emerald center.

Getting to Keketuohai required a large pack of gear, multiple days of travel, permission from the local government, permission from the border patrol, permission from park security, and, before all that, permission from Tricia, which may have been the hardest red tape I had to cut—letting me journey halfway around the world, with now two young children back at home.

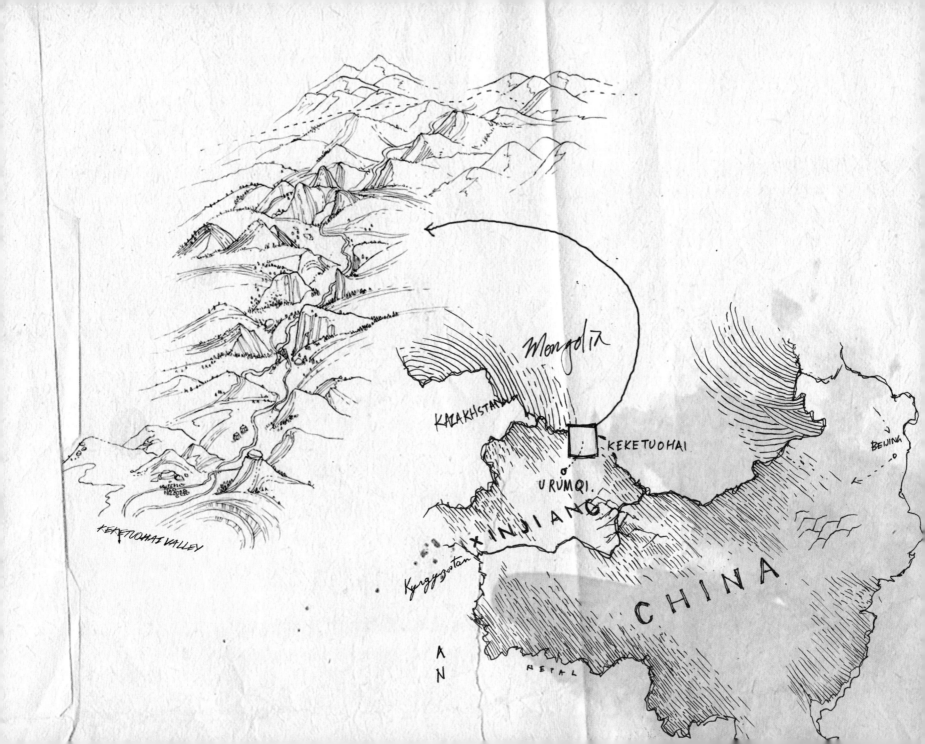

OUR POINT OF ENTRY WAS URUMQI,

site of riots between the Uyghurs and Han Chinese a year earlier; when I woke in the morning, the government's presence was instantly apparent.

" A cab driver told me that **"if something goes down"** I should run to my hotel, a popular Muslim hideout.

Urumqi (yer-um-chi) is a "small" city of 11 million people, all crammed into high-rises that disappear into the clouds. With traffic and people bumper to bumper and elbow to elbow, it's an unlikely place to begin a soul-searching journey into the mountains.

From Urumqi, we drove 10 hours to the valley. When we arrived, we were confused to find that the canyon was no longer a national geological site, but had been purchased from the government by a businessman who was turning it into some kind of natural tourist attraction, a developed national park. Hundreds of locals from the nearby village had been given jobs to help make this vision a reality.

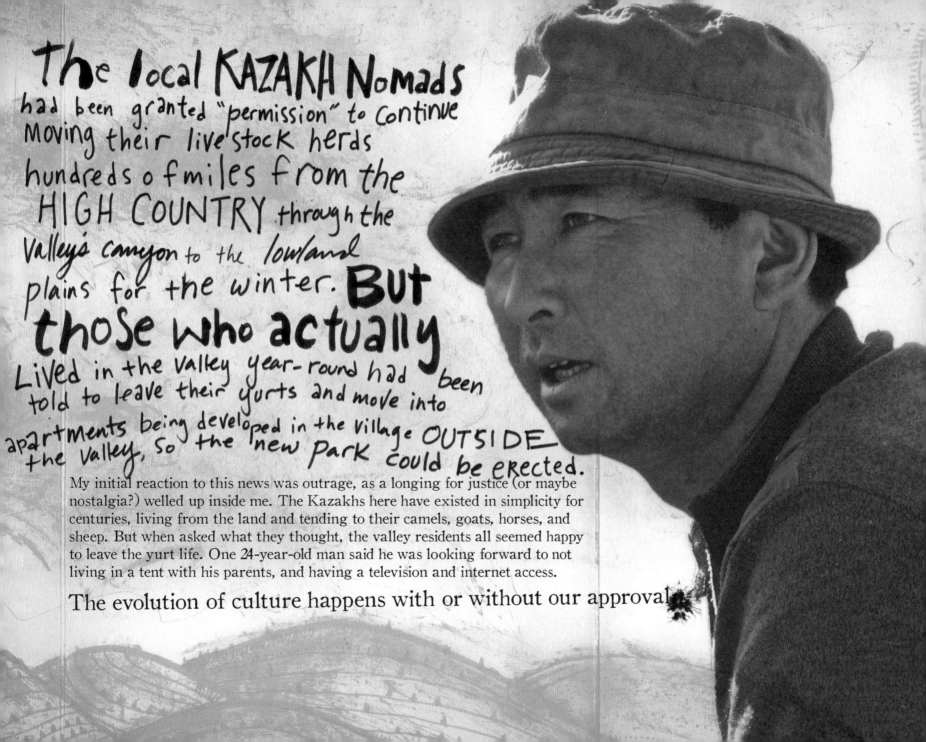

The local KAZAKH Nomads

had been granted "permission" to continue moving their livestock herds hundreds of miles from the HIGH COUNTRY through the valley's canyon to the lowland plains for the winter. BUT those who actually lived in the valley year-round had been told to leave their yurts and move into apartments being developed in the village OUTSIDE the valley, so the new park could be erected.

My initial reaction to this news was outrage, as a longing for justice (or maybe nostalgia?) welled up inside me. The Kazakhs here have existed in simplicity for centuries, living from the land and tending to their camels, goats, horses, and sheep. But when asked what they thought, the valley residents all seemed happy to leave the yurt life. One 24-year-old man said he was looking forward to not living in a tent with his parents, and having a television and internet access.

The evolution of culture happens with or without our approval.

The Irtysh river was the vital source of life in THE VALLEY, but it also held the great granite domes we came to climb. NO ONE had come here to climb them BEFORE, SO WE WERE something of a spectacle, a small herd of white people with OVER SIZE packs AND colorful, stretchy clothes. We were WARMLY welcomed with SMILES AND Waves.

Despite the friendliness, bureaucracy was a nightmare. I took the backseat and let Mark handle the
politics, since he knew his way around a jail cell better than the rest of us. Eventually, between
the Mongolian border patrol, park security, and some aligned stars, we were allowed to climb.
We made our way into the park and to the river's domes. Our necks craned to the sky, pointing out
lines, picking the most climbable-looking features on the immaculate blank white rock.

This granite was our canvas; our hands and feet, our brush and paint to express and explore.

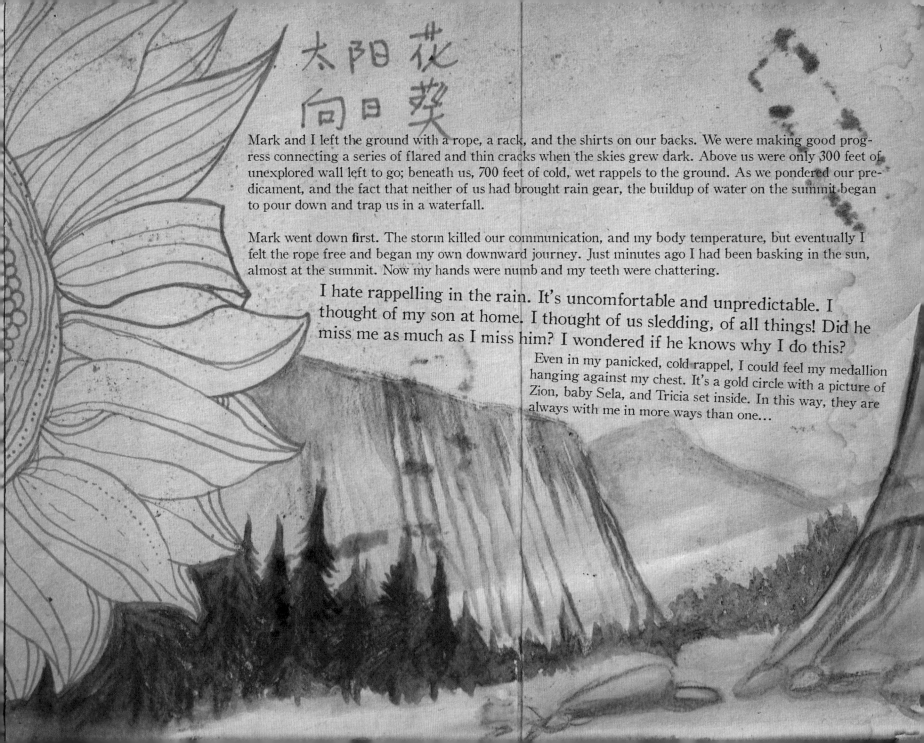

太阳花
向日葵

Mark and I left the ground with a rope, a rack, and the shirts on our backs. We were making good progress connecting a series of flared and thin cracks when the skies grew dark. Above us were only 300 feet of unexplored wall left to go; beneath us, 700 feet of cold, wet rappels to the ground. As we pondered our predicament, and the fact that neither of us had brought rain gear, the buildup of water on the summit began to pour down and trap us in a waterfall.

Mark went down first. The storm killed our communication, and my body temperature, but eventually I felt the rope free and began my own downward journey. Just minutes ago I had been basking in the sun, almost at the summit. Now my hands were numb and my teeth were chattering.

I hate rappelling in the rain. It's uncomfortable and unpredictable. I thought of my son at home. I thought of us sledding, of all things! Did he miss me as much as I miss him? I wondered if he knows why I do this?

Even in my panicked, cold rappel, I could feel my medallion hanging against my chest. It's a gold circle with a picture of Zion, baby Sela, and Tricia set inside. In this way, they are always with me in more ways than one...

We made it down safely, and eventually the storms passed. We spent the evening with a camel-herding Kazakh family.

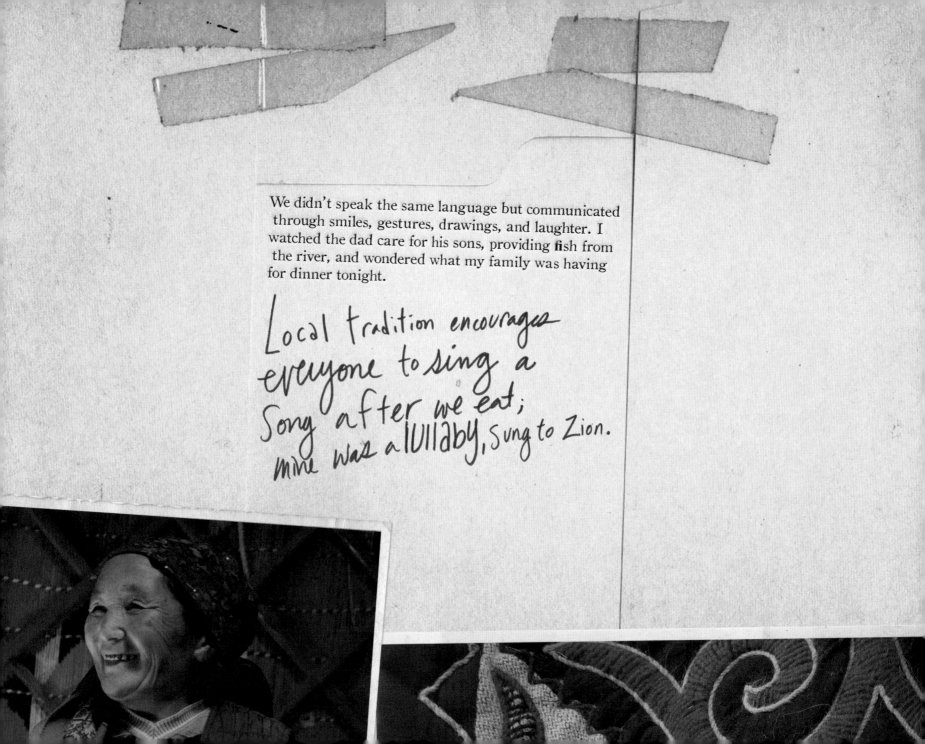

We didn't speak the same language but communicated through smiles, gestures, drawings, and laughter. I watched the dad care for his sons, providing fish from the river, and wondered what my family was having for dinner tonight.

Local tradition encourages everyone to sing a song after we eat; mine was a lullaby, sung to Zion.

After a long day on the wall, sleep came easy in the yurt, and I fell asleep dreaming of my son and me growing **Old together.**

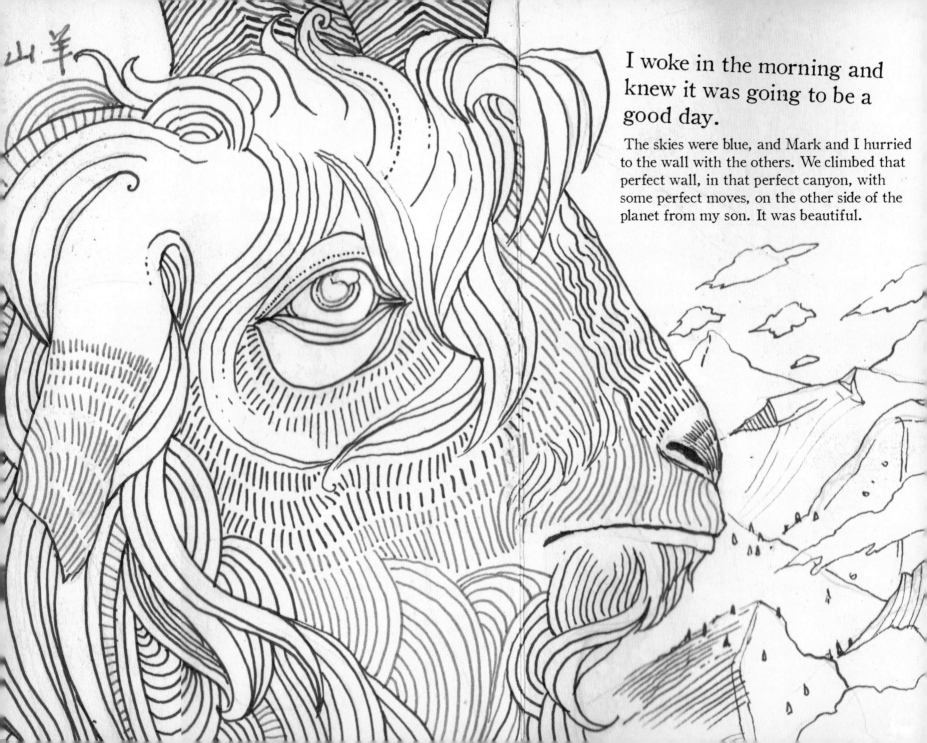

I woke in the morning and knew it was going to be a good day.

The skies were blue, and Mark and I hurried to the wall with the others. We climbed that perfect wall, in that perfect canyon, with some perfect moves, on the other side of the planet from my son. It was beautiful.

Dear Zion,

I am writing to you from on top of a small granite peak in Northern China. Its name is "Small Bell Hill." To my right I look down canyon along the Irtysh River in the valley Keketuohai.

To my left I look up canyon into Southern Mongolia. Beneath me is the route I just climbed to get to the top. Above me is... well... sky. But not just _any_ sky. It's a perfect blue splitter sky, with small wisps of clouds, and a lone eagle eyeing me from way up there, wondering how I got here.

You'd love it.
Miss you.

Love,
dad

And on the summit, I smiled: **EAST.**

Jonny flew over the Irtysh River.
And I thought of some things I wanted to teach Zion...

For Whom the Bell Tolls
(Wolf and the Medallion)
5.11.

Try your best to make the complex simple, and the simple complex. (if you can figure out _how_ to do this, let me know)

Make money to live life and never the opposite.

Say YES to opportunities that will shape you in the long run, even if it means sacrificing opportunities that benefit you in the short run.

Be an active steward of the earth,
Be aware and be involved in the story of our planet.

You will never understand women. But always respect them.

Find the outcasts. Make them feel welcome.

Share.

If Something terrifies you,
it's probably best to Consider doing it. *

* case dependent

If you are having trouble finding a path in life, good.
To quote Lao Tzu, "Nature does not hurry, yet all is Accomplished."

Never let complacency catch you.

SOUTH PART I

Gold is more than mineral

"*Adversity makes men, and prosperity makes monsters.*"

— Victor Hugo

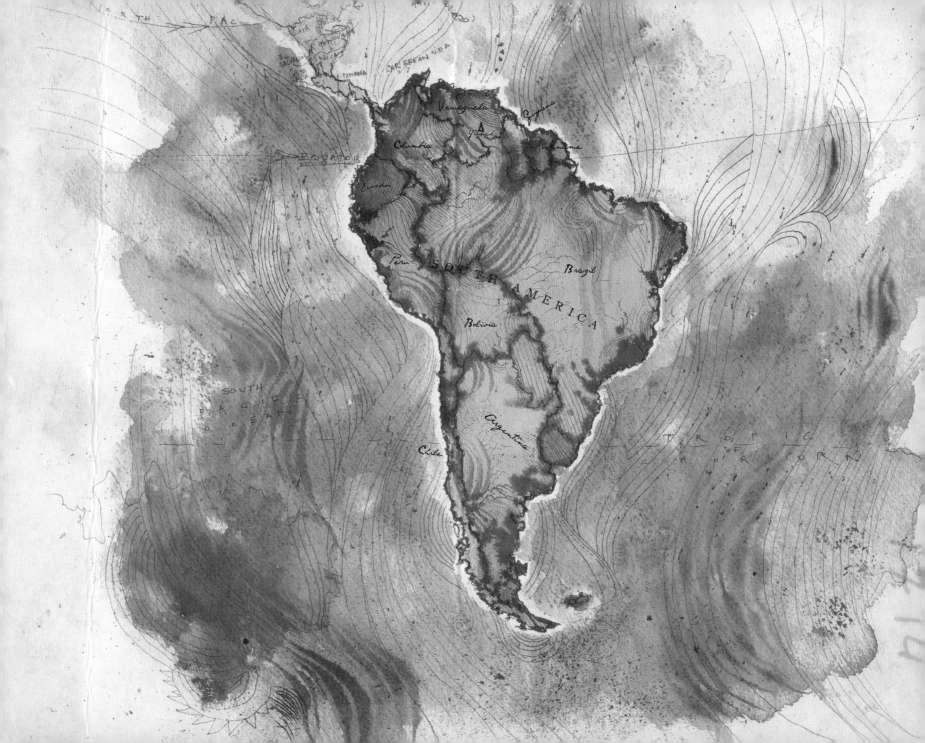

Rising from the canopy of the vast and diverse GRAN SABANA jungle in Venezuela are massive projections of PRE-CAMBRIAN sandstone, some of the oldest on the planet. These rust-colored mesas are called TEPUIS (teh-poo-ees), meaning "houses of the gods," by the indigenous PEMON TRIBES, who have inhabited the region for centuries.

The aura and/ore that surround them certainly inspire a deep and holy respect. Reaching heights of 1,000 METERS above the jungle, the summits promise a twisted maze of ornate rock structures, delicately sculpted over the eons surely by the breath of god.

Each tepui houses its own ecosystem, different than that of the valley below, with flora and fauna seen nowhere else in the world. These breathtaking ecological islands have for the most part avoided the onslaught of tourism to their summits. There is simply no easy way to the top of most of the 115 official, mapped tepuis other than helicopter—or vertical ascent.

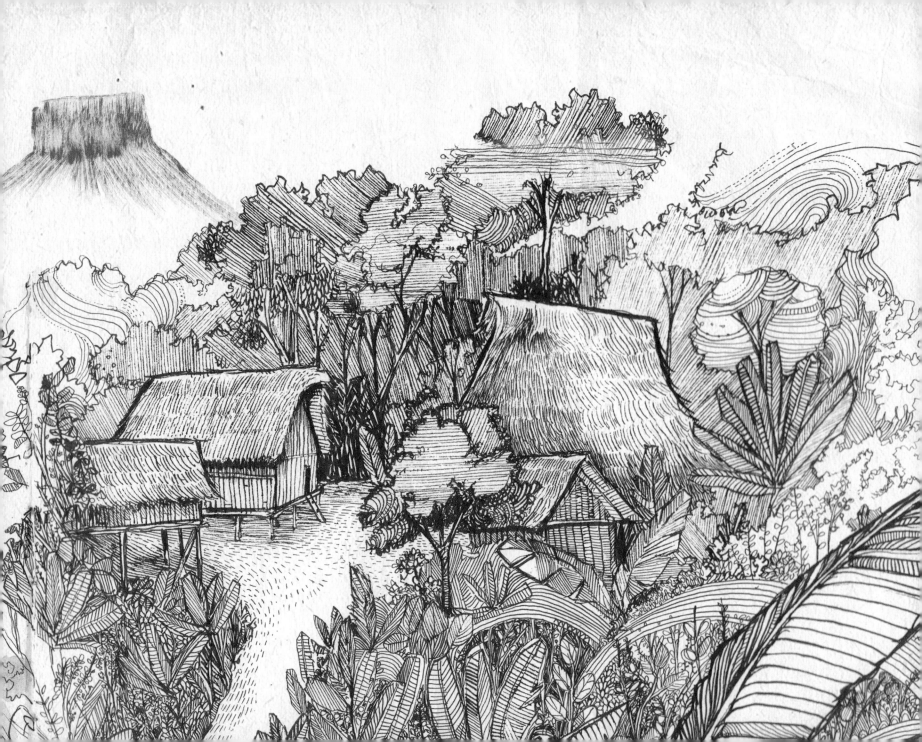

I talked my friend Pat Goodman into going south to Venezuela with me. pat is a wood-floor installer from West Virginia with many expeditions under his belt.

He's built like a fist—a stout, brawny, redheaded Irishman with a fire in his eyes. On the rock, in the mountains, or on the job site, he attacks with a brute force matched only by his wit and spirit.

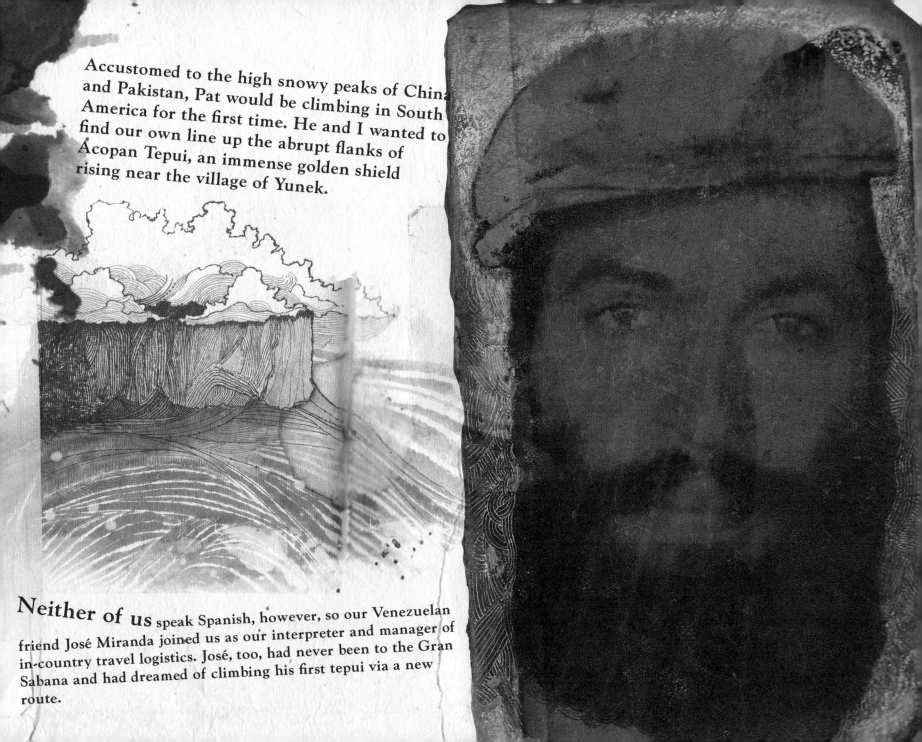

Accustomed to the high snowy peaks of China and Pakistan, Pat would be climbing in South America for the first time. He and I wanted to find our own line up the abrupt flanks of Acopan Tepui, an immense golden shield rising near the village of Yunek.

Neither of us speak Spanish, however, so our Venezuelan friend José Miranda joined us as our interpreter and manager of in-country travel logistics. José, too, had never been to the Gran Sabana and had dreamed of climbing his first tepui via a new route.

JOSE runs a water buffalo farm with his family on the outskirts of CARACAS, where his daughter PAS made us smoothies from the garden and his son KAWAK played the piano for us to inspire our journey before we hit the road.

Pas Miranda

When I saw the rig José had for us to drive across the entire country—a multi-colored 1967 Land Rover that he was slowly but surely bringing back from the grave, one bolt and bungee cord at a time—I started to question his role as manager. But we filled it with food from the farm, and off we went.

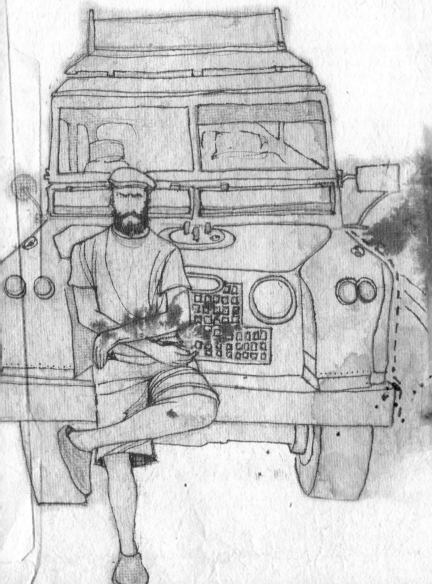

Riding in the Tank, as we lovingly nick-named the Land Rover, was an adventure in itself. Each Grand Canyon–size rut in the road sent everything airborne—bags, ropes, tools, and dudes, all suspended in midair for a momentary breath, as if we were in the antigravity chamber at NASA. In the backseat, Pat would moan and brace for another bruising. I'd land with a dull thud in a metal-meets-bone collision that I eventually grew accustomed to.

We'd pause occasionally for the Tank to catch its breath (overheat, blow a head gasket, or drop a belt). Each time, José, also a skilled mechanic, would pull out his toolbox like a paramedic at a trauma scene, covered in motor oil, then emerge from his surgery declaring success.

We raced nightfall along a Venezuelan "shortcut" — me half awake and half terrified, my eyes glossed over but hidden behind polarized shades. In his right hand, José gripped his signature dirty white driver's cap, the ever-present accent to the 18-inch beard that hung from his face like a bag of steel wool.

We were catapulting down a one-lane dirt road toward the airport in Ciudad Bolívar, a two-day drive from Caracas, from which we would fly even farther south, into the Gran Sabana jungle.

Finally bumping into Ciudad Bolívar late at night, we piled up in a hotel room to wait for a plane.

Ciudad Bolívar Pilot Progress Report

Day One: Pilot is missing parts for his plane.

Day two: Pilot says it's too rainy.

Day three: "OK Gringos, get in the plane. It should work now."

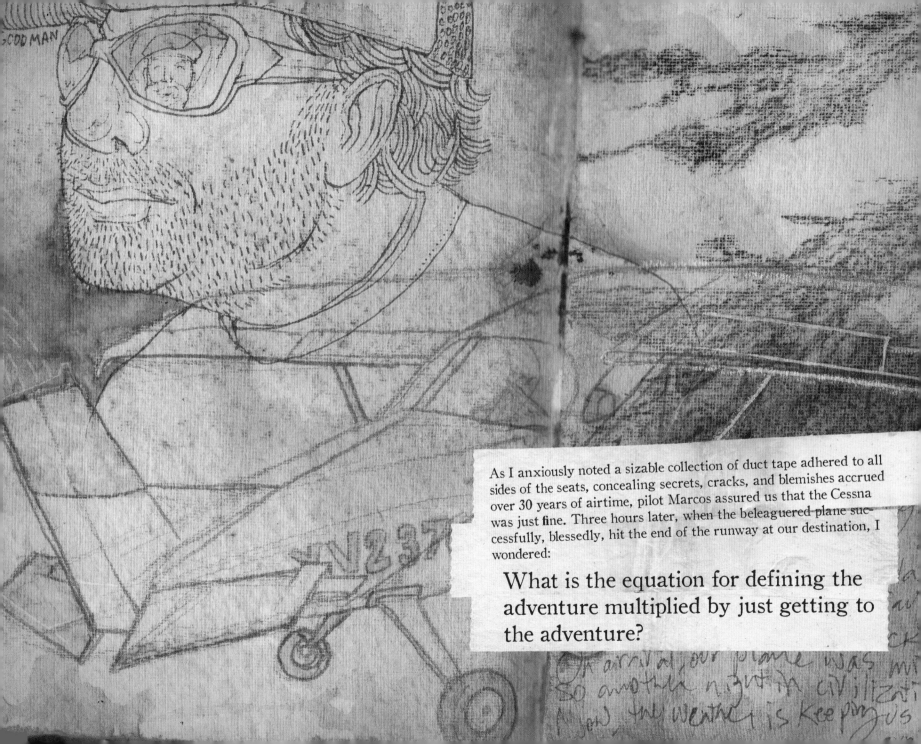

As I anxiously noted a sizable collection of duct tape adhered to all sides of the seats, concealing secrets, cracks, and blemishes accrued over 30 years of airtime, pilot Marcos assured us that the Cessna was just fine. Three hours later, when the beleaguered plane successfully, blessedly, hit the end of the runway at our destination, I wondered:

What is the equation for defining the adventure multiplied by just getting to the adventure?

FROM Thatched huts and makeshift tin-shed HOMES emerged a smattering of the villagers of YUNEK. WITH A POPULATION of ONLY 72, many of them were related in one way or another. As the buzz of MARcos's plane faded, We were immediately greeted by Leonardo, the viallge chieftain. With warm eyes he Welcomed us, inviting us to sit.

An elderly Woman delivered a plate of pineapple slices, and we explained that We wanted to climb ACOPAN TEPUI.

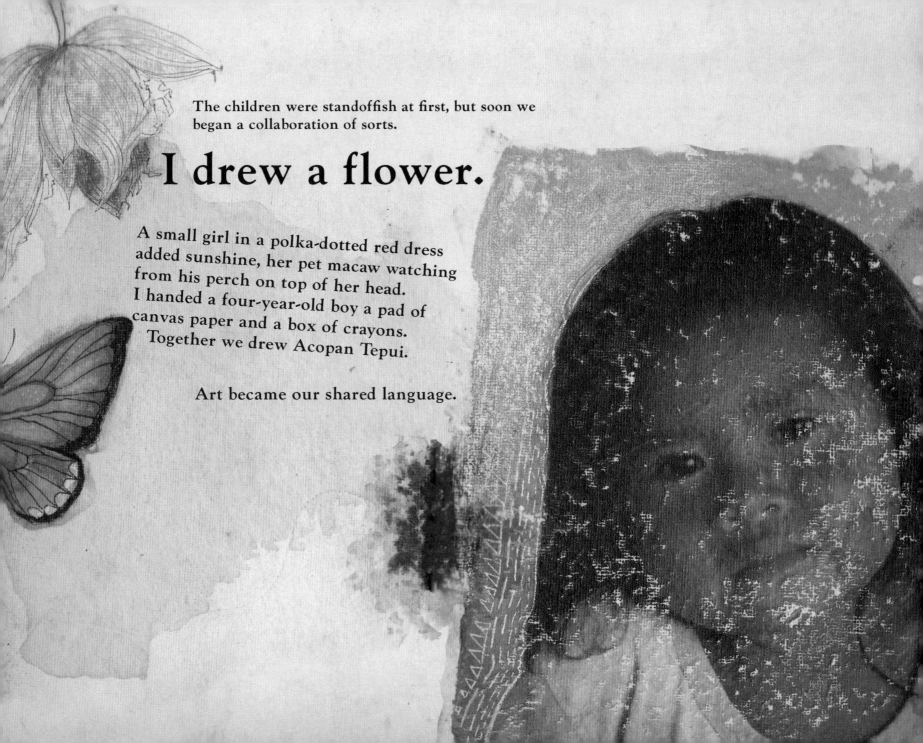

The children were standoffish at first, but soon we began a collaboration of sorts.

I drew a flower.

A small girl in a polka-dotted red dress added sunshine, her pet macaw watching from his perch on top of her head. I handed a four-year-old boy a pad of canvas paper and a box of crayons. Together we drew Acopan Tepui.

Art became our shared language.

We quickly learned that the village had simple needs: SUN, RAIN, AND COMMUNITY. BUT, they also had a small generator they used to power their emergency CB radio, some lights for cook- ing and even a karaoke machine. TO refuel, they travelled three days up the KUKENÁN town RIVER by small dugout canoe to the of SANTA ELENA de Uairén. There they filled their collection of gas tanks and traded produce for other supplies, then journeyed three days back.

The primary threat to their way of life was from illegal mining for gold. While the government looked the other way, the miners' extraction process poisoned village water supplies with mercury, and despoiled the surrounding jungle habitat.

Allowing climbers access to these jungles was a more appealing proposition, and Leonardo assigned five porters to help us to base camp. After a half-day hike from the village, we were beneath the great Acopan—the towering crimson HOUSE OF THE GODS, which was vastly more complex than I had comprehended when looking at photos and topographic maps. Imagine zooming into a macro view of a wadded-up ball of tinfoil, and you might get a hint of how featured and dimensional this massif is.

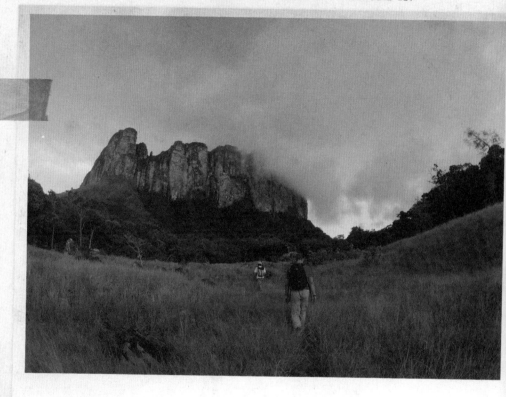

The terrain varies from uniform, flawless 1,000-foot-tall unfractured faces to dark, overhung corners choked up entirely with cactus and yucca plants. And on the ground, one must watch out for the venomous fer-de-lance viper. With fangs over an inch long, the fer-de-lance is the undisputed king of the jungle. One was found here just a week ago, the porters tell us as they wish us well and return to Yunek.

Other things to watch Out for:

Anacondas

SAKi's

mosquito

Scorpions

Constrictors

Ocelots

Jaguar

porcupines

BLACK widows

BANANA spiders

Recluses

Ticks

Tarantulas

5"

Blackflies

Live poison dart frog

Pumas

In the morning, we started our approach to the WALL. UPON LEAVING the grassy savanah, we entered the darkness of the jungle canopy as if stepping directly from day into night I CHECKED MY WATCH: only an illusion. We fought through a mile of thick jungle undergrowth, gripping wet exposed roots of gnarled trees to PULL OUR selves upward.

This jungle exertion merged into just-under-vertical grass climbing, perched on an 18-inch-wide trail with a vertical drop of 200 feet on either side, as if we were ascending a grass-covered arch of the Golden Gate Bridge. We dubbed it "disaster hiking."

While Pat curled up on a ledge to throw up and eat some ibuprofen for lunch, I climbed hand over hand up a dangling

30-foot vine to a pedestal where José and I started on difficult rock. The holds were thin, and a flow of water seeped in-

cessantly from the surface. I dabbed my shirt on the holds till they stayed dry long enough for me to climb past; just

seconds later, they were wet again. Fifty feet to our left, a roaring 100-meter waterfall fed into the darkness below.

When the wind blew, the rock got more soaked with water. When there was no wind, it was boiling hot.

Somewhere beneath me, a group of HOWLER monkeys called OUT a greeting to us on the wall.

"GRUNK!
GRUUNK!"

I called back.

"Helllloooo...
BROTHERS!"

I gripped the glassy rock a little tighter and eventually arrived at the top of the first rope-length. We called it a day, then started the same pattern in the morning, moving the rope through ever steepening rock—not just burrowing upward in a straight line, but connecting features and promising corners, moving as a team of artists "painting" a collaborative picture. Small storms would cross the savannah like drifting ships. The sun was brilliant on our backs, and it was hard to hide from sunburn. Despite a continuing headache, Pat led through the blankest face yet, navigating around a large nest of wasps, each seemingly as big as a Swiss Army knife.

Then came day four on the wall, and it was José's turn to take over the lead responsibilities.

He tied in,
took all the gear,
and stepped off into the
unknown.

"**should I go left or right first, doodz?**"

"Hard to say, amigo," I said.

"I suggest just getting up there and evaluating."

José stood four feet above and five feet to the left of me, perched on a blank face, holding on by his toes and fingertips. I grasped the rope and leaned in the opposite direction from him. This was his first lead of the trip, and the first time Pat or I had seen him on unclimbed terrain. We didn't know what to expect. As José fiddled with his precarious-looking gear, working it into a wet crack, Pat and I looked at each other, wide-eyed. José's leg was jittering on an edge, and his breathing was increasing in intensity.

"Amigo, I don't think that gear is any good," Pat offered.

No one likes a backseat climber, but this was right above us, and a fall could be dangerous to the whole team.

José had our full attention.

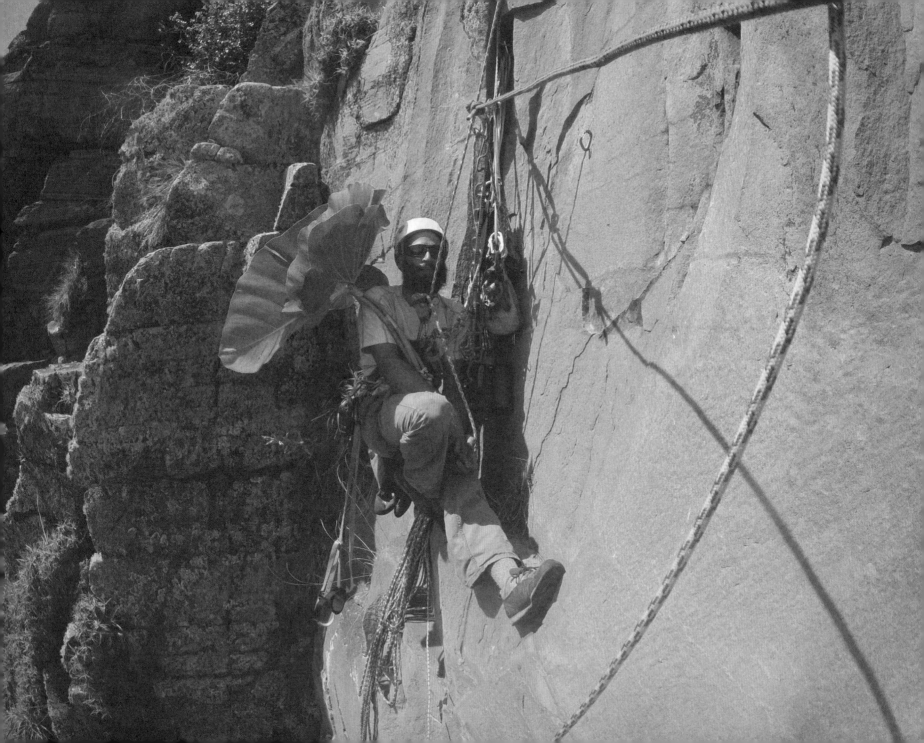

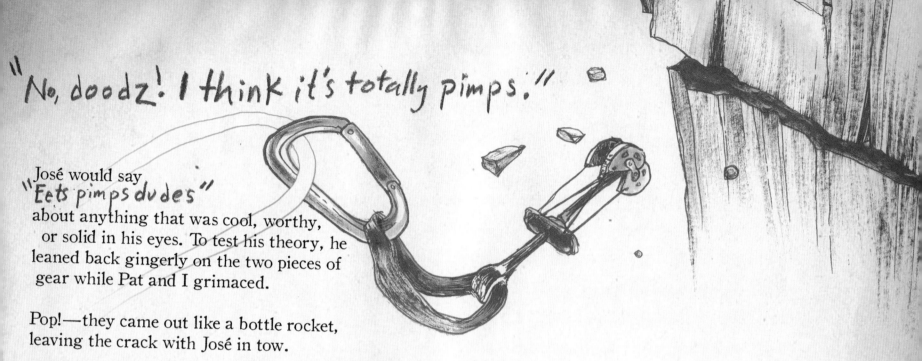

"No, doodz! I think it's totally pimps."

José would say "Eets pimps dudes" about anything that was cool, worthy, or solid in his eyes. To test his theory, he leaned back gingerly on the two pieces of gear while Pat and I grimaced.

Pop!—they came out like a bottle rocket, leaving the crack with José in tow.

Not pimps. Not pimps at all.

José took a violent swing into the ledge and smacked his ankle against the wall. "Ay!" he yelped as he dangled in space, spinning like a Venezuelan piñata. Blood trickled from his ankle down into his shoe. I pulled him to the ledge for a drink of water and a re-assessment. A lone bird wailed overhead. Its body glowed white against its black head, its 10-foot wingspan riding the currents high above. A king vulture. José took its presence as a sign to carry on.

He returned to his high point with a new battle plan. He put two new pieces of gear, which looked only slightly better from our vantage point, into the crack. With renewed confidence he stepped up high on a micro-edge, shuffled his hands across a half-inch rail, and stepped two feet left. Pat and I watched quietly as the waterfall now beneath us provided white noise in the background.

José dipped his hand in his chalk bag to dry the sweat. The wind blew the white powdered chalk into a swirling mini-snowstorm. He took a deep breath and initiated his next series of moves. He was now above and sideways three feet from the wet crack with the newly placed gear. He looked down at his protection for one more boost of confidence.

And then...

José was airborne again. He was coming down and sideways toward me. I gripped the rope, turned my face away, and braced for impact. And then— **tWap!** —the gear he had placed popped again, firing from the rock violently as he passed by us, hitting the wall just below in a loud crash of aluminum, body, and rock.

José bellowed in agony and again spun in space. Hanging from the rope, he grabbed at his ankles.

"I think I've BROKEN my ankle, doodz!"

"I'm sure it's not that bad," I said.

"Let's get you over here."

Somehow we got José back to our little ledge. The sun had now abandoned us, and there wasn't much daylight left. José's ankles began to swell like two purple grapefruit. Getting him down to base camp was no easy task, but we managed, using makeshift crutches of fallen tree limbs and duct tape.

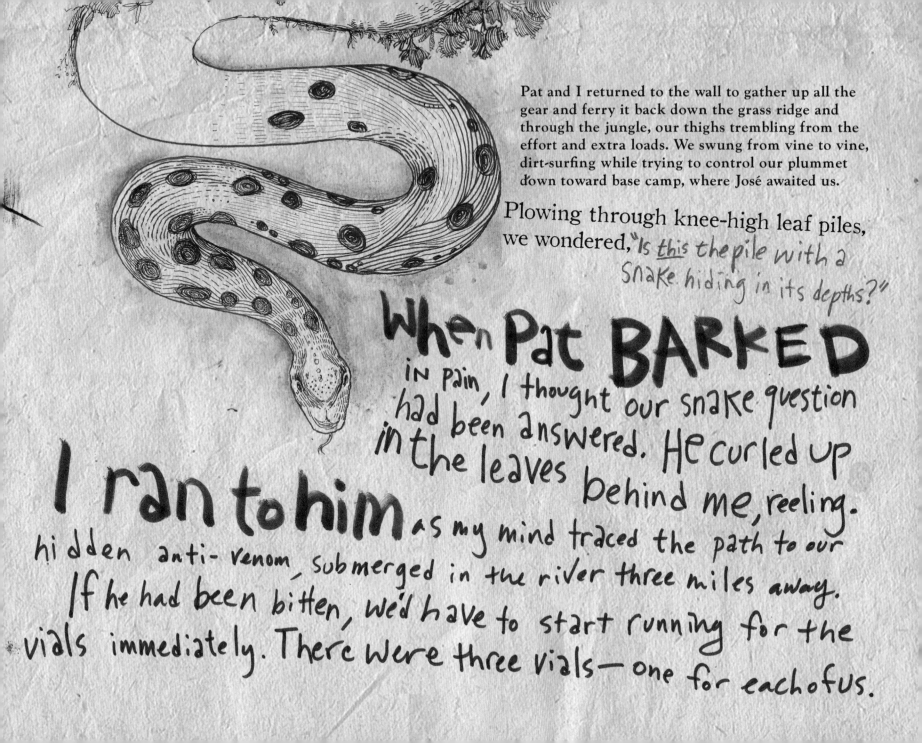

Pat and I returned to the wall to gather up all the gear and ferry it back down the grass ridge and through the jungle, our thighs trembling from the effort and extra loads. We swung from vine to vine, dirt-surfing while trying to control our plummet down toward base camp, where José awaited us.

Plowing through knee-high leaf piles, we wondered, "Is _this_ the pile with a snake hiding in its depths?"

When Pat BARKED in pain, I thought our snake question had been answered. He curled up in the leaves behind me, reeling.

I ran to him as my mind traced the path to our hidden anti-venom, submerged in the river three miles away. If he had been bitten, we'd have to start running for the vials immediately. There were three vials—one for each of us.

But it wasn't a snakebite.

In his momentum, Pat had caught his hand on a rock hidden under the leaves. His middle finger was sliced and bloodied and already swollen—not as big as a grapefruit, but maybe the size of a stuffed Italian sausage.

We sat there in the jungle inspecting the damage. Pat's climbing was over for now. Maybe for a long while. He soaked his hand in a nearby creek while I cleaned my face, digging dirt from my ears, nostrils, and eyelids.

We were silent as the creek gurgled its song, the macaws crooned, and howlers screamed in the distance.

The shadows of the jungle canopy danced on the ground in a earthen kaleidoscope. I watched sideways as Pat fiddled with his finger, hoping for any positive sign. Back at base camp, we joined the various bugs in our tent for a restless night under a full moon.

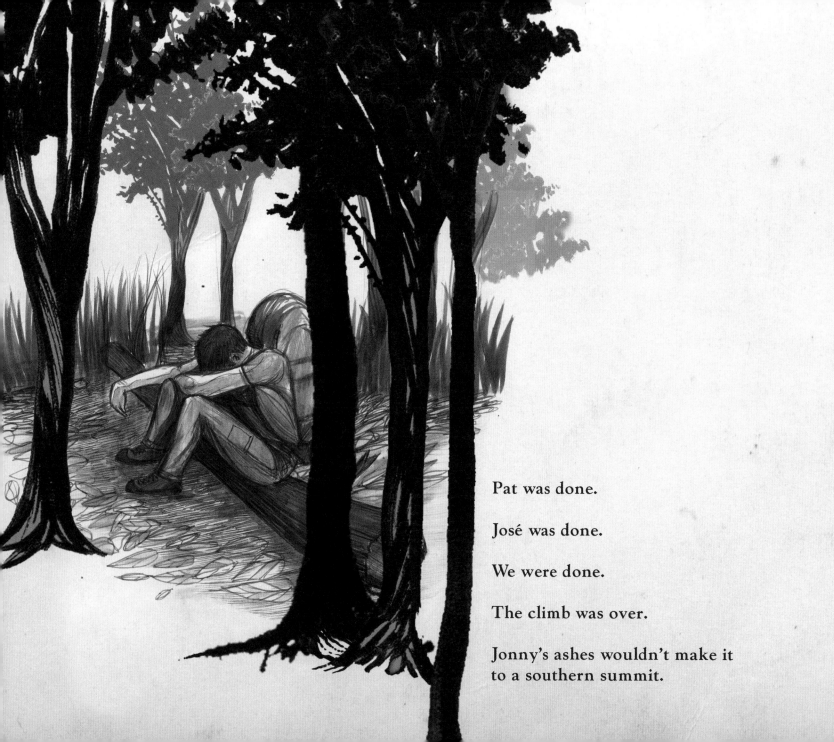

Pat was done.

José was done.

We were done.

The climb was over.

Jonny's ashes wouldn't make it
to a southern summit.

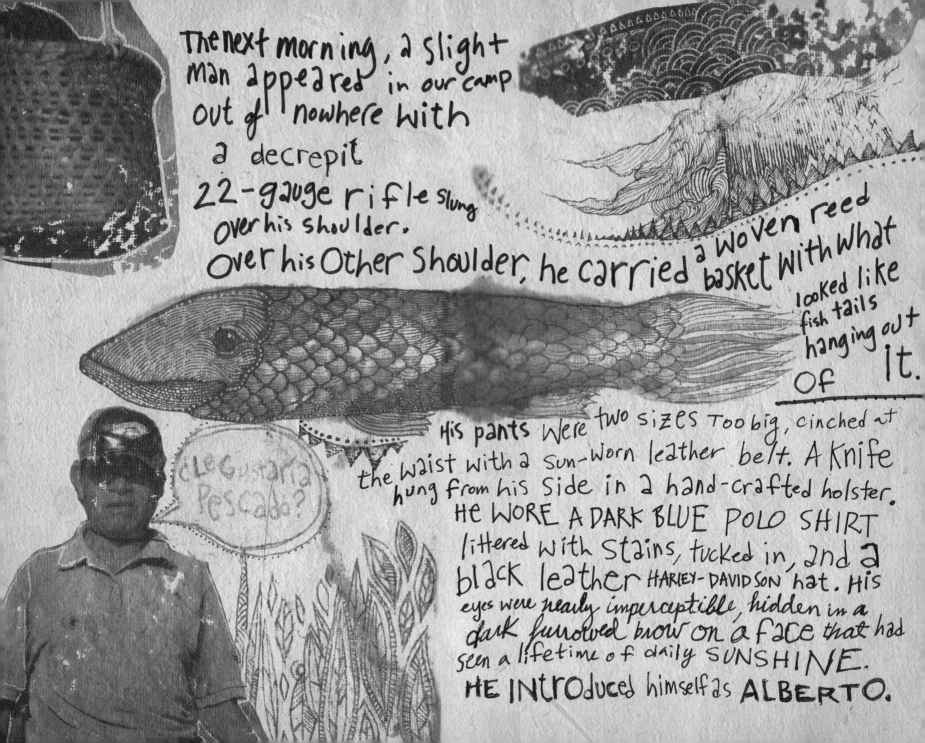

The next morning, a slight man appeared in our camp out of nowhere with a decrepit 22-gauge rifle slung over his shoulder. Over his other shoulder, he carried a woven reed basket with what looked like fish tails hanging out of it.

¿Le Gustaría Pescado?

His pants were two sizes too big, cinched at the waist with a sun-worn leather belt. A knife hung from his side in a hand-crafted holster. HE WORE A DARK BLUE POLO SHIRT littered with stains, tucked in, and a black leather HARLEY-DAVIDSON hat. His eyes were nearly imperceptible, hidden in a dark furrowed brow on a face that had seen a lifetime of daily SUNSHINE. HE INTRODUCED himself as ALBERTO.

He wanted to trade some fish for batteries if we had some to spare. He lived in a homestead outside of Yunek but spent most of his time in the village's gardens, currently a day's walk away.

We shared his fish, and Alberto spent the next two days in camp, teaching us how to make a woven basket like his—and distracting us while we waited out our injuries and a steady rain.

We asked him about everything Pemon, and he was happy to share: "Young men must learn three things before they are allowed to seek a wife."

Alberto would take long pauses after cliffhangers like this, enjoying watching us anticipate his words from the corner of his eye. He whittled at a stick while he talked.

"They must first learn to hunt by making their own weapons."
Long pause.

"Then they must build a canoe from a tree,"
Long pause,

"And finally they must build a home from what they gather in a forest."

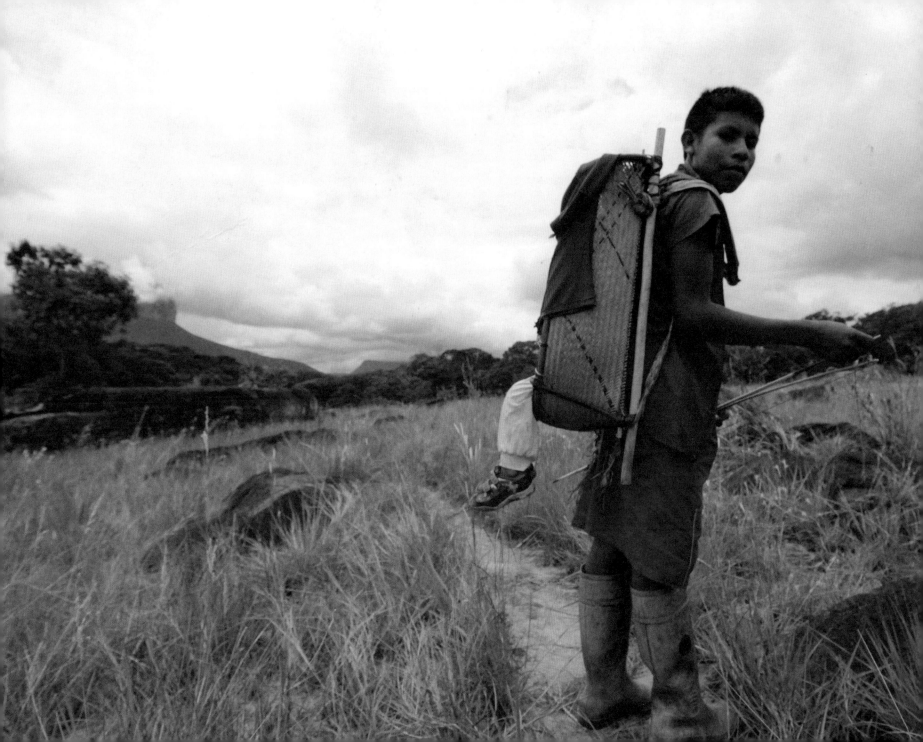

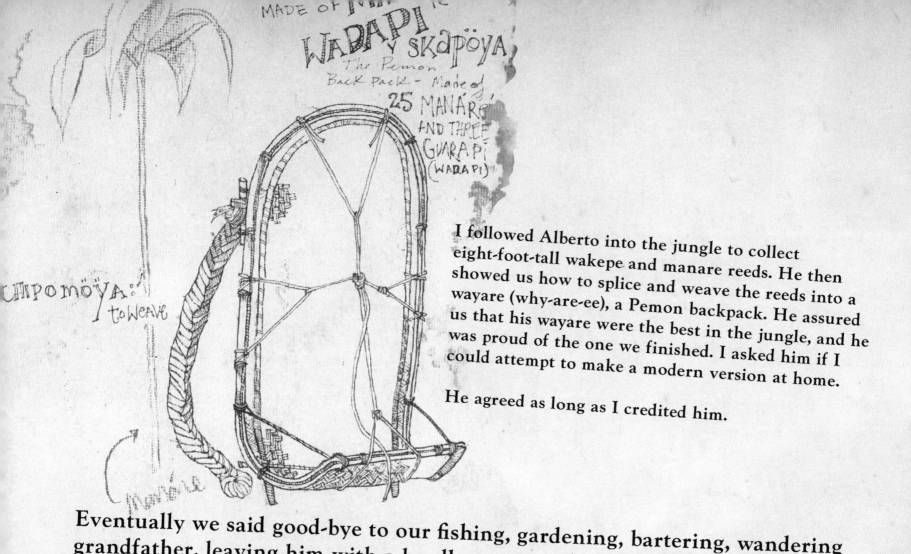

MADE OF I~~

WADAPI Y SKAPÖYA

The Pemon
Back pack - Made of
25 MANÁRE
AND THREE
GUARAPI
(WADAPI)

CHPOMÖYA:
Y toWEAVE

manáre

I followed Alberto into the jungle to collect
eight-foot-tall wakepe and manare reeds. He then
showed us how to splice and weave the reeds into a
wayare (why-are-ee), a Pemon backpack. He assured
us that his wayare were the best in the jungle, and he
was proud of the one we finished. I asked him if I
could attempt to make a modern version at home.

He agreed as long as I credited him.

Eventually we said good-bye to our fishing, gardening, bartering, wandering
grandfather, leaving him with a headlamp, more batteries, and a walkie-talkie.
Frustrated, bug-bitten, and broken, we slowly reversed our trek-to-village-
to-plane-to-Tank journey back to Caracas, stopping at a roadside clinic along
the way and confirming fractured bones for both Pat and José.

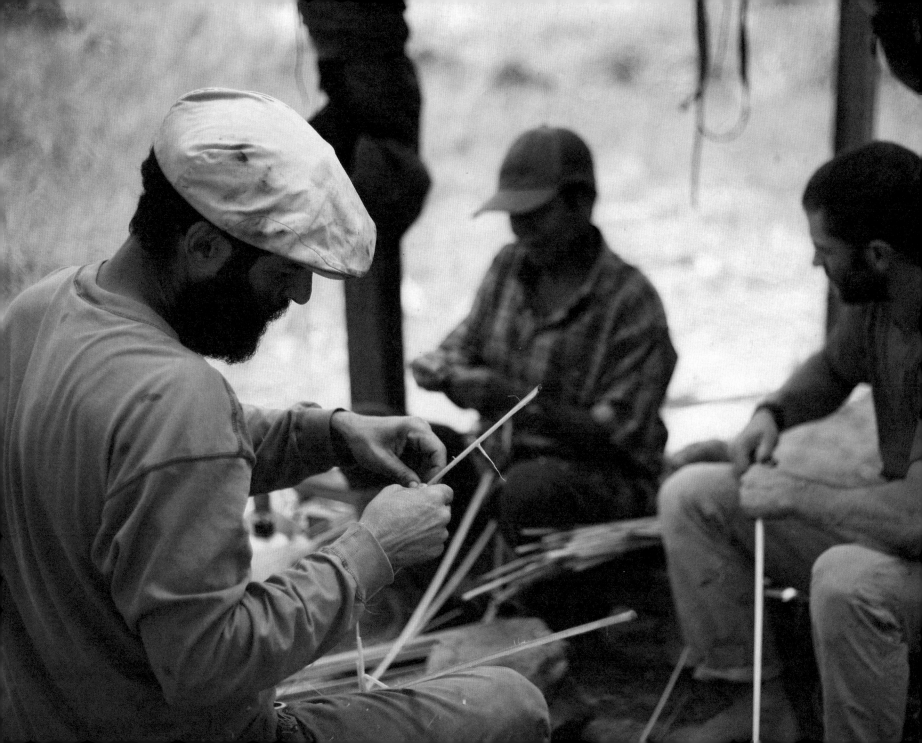

Before we left Caracas, José brought us to his grandparents' apartment in the city for a nice home-cooked meal. When we arrived, Señora Miranda served us tea and cake, which we devoured like street dogs.

José's grandfather had recently had a stroke, limiting his ability to talk, walk, or move around. A primary-care physician, Dr. Miranda was being honored soon with a lifetime achievement award. He was 96 years old, with thin grey hair, a curved back, and a constant hacking cough that ricocheted off the apartment walls.

Their home was filled with an amazing variety of art collected from their travels. I asked Dr. Miranda if he would give Pat and me a tour of his art collection. He shuffled ahead of us, mumbling in half Spanish/half English, pointing out the finer details of the paintings, sculptures, and drawings.

We moved into his office, where on the wall hung his many certificates and awards, each ornately framed. He paused here with his hands behind his back, watching us much younger men take it all in. The walls were of dark wood, the carpet a red shag with a large oak desk in the middle of the room covered in papers and books. It smelled fresh, not old and musty as you might anticipate; sunshine filtered through a window from behind louvered shades.

Through his difficult breathing and slurred speech, Dr. Miranda announced, with a gesture to his certificates, "None of this is important". He placed his weathered hand on my arm and reached over to a closed closet door. He opened it carefully to reveal photos and family notes taped inside. Pat and I marveled at a yellowing black-and-white photo of a man doing a handstand on the seat of a folding chair at the side of a pool.

"Wow, is that you, señor?"

Dr. Miranda's breathing became deeper, and he began to cry as his grip became tighter on my arm. The cry became a sob and I knew this was a powerful moment for him. He pointed with a crooked finger to the picture and said clearly, "This is what matters," and then he pointed at a portrait of his family— "and this" —and what was presumably a note from his wife carefully taped nearby— "and this".

Returning to the handstand image, he added, "I could do this up until 10 years ago... and now I can't."

Amid his tears, he advised us to "never stop doing the things you love."

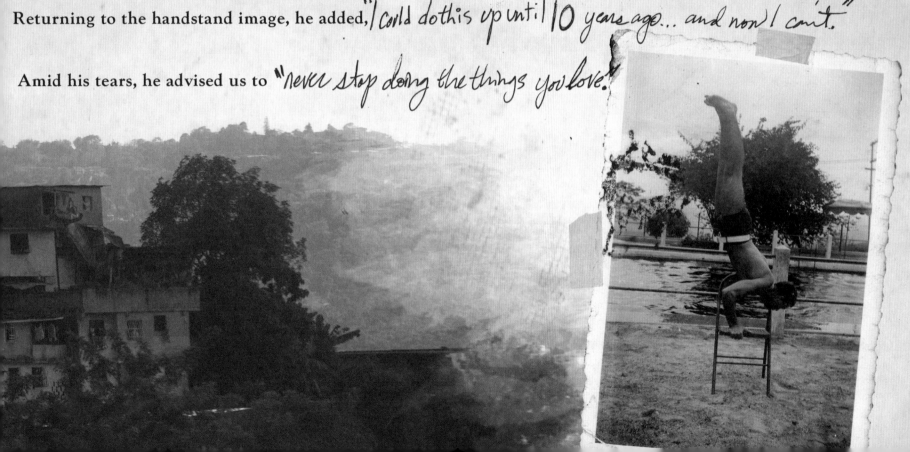

I thought about the route we had just abandoned in the jungle, and how the summit didn't matter as much as the experience of being there, fully committed to a difficult objective with friends.

I thought of Jonny.

I thought of my family waiting at home.

I thought about what matters.

I also wondered if I would ever be able to do a handstand in my 80s, let alone on the edge of a chair.

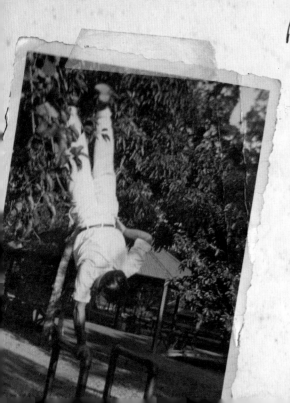

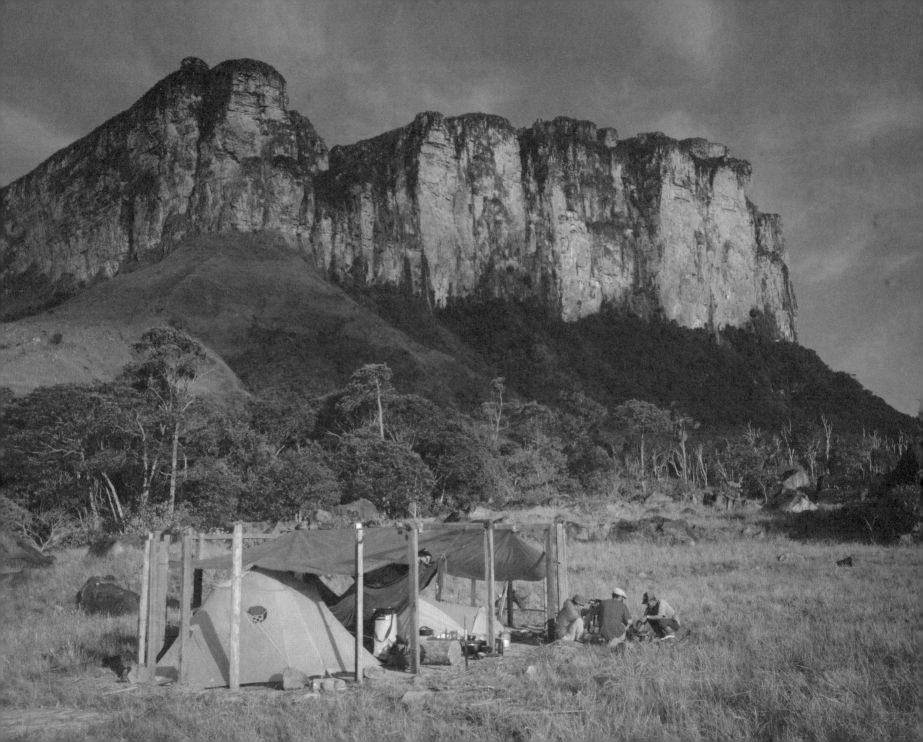

CHAPTER 4:

Rising

"Life is a storm, my young friend. You will bask in the sunlight one moment, be shattered on the rocks the next. What makes you a man is what you do when that storm comes. You must look into that storm and shout, Do your worst, for I will do mine!"

—Alexandre Dumas

The Count of Monte Cristo

Many Shot, Siksika (Blackfoot)
First Nations, Canada

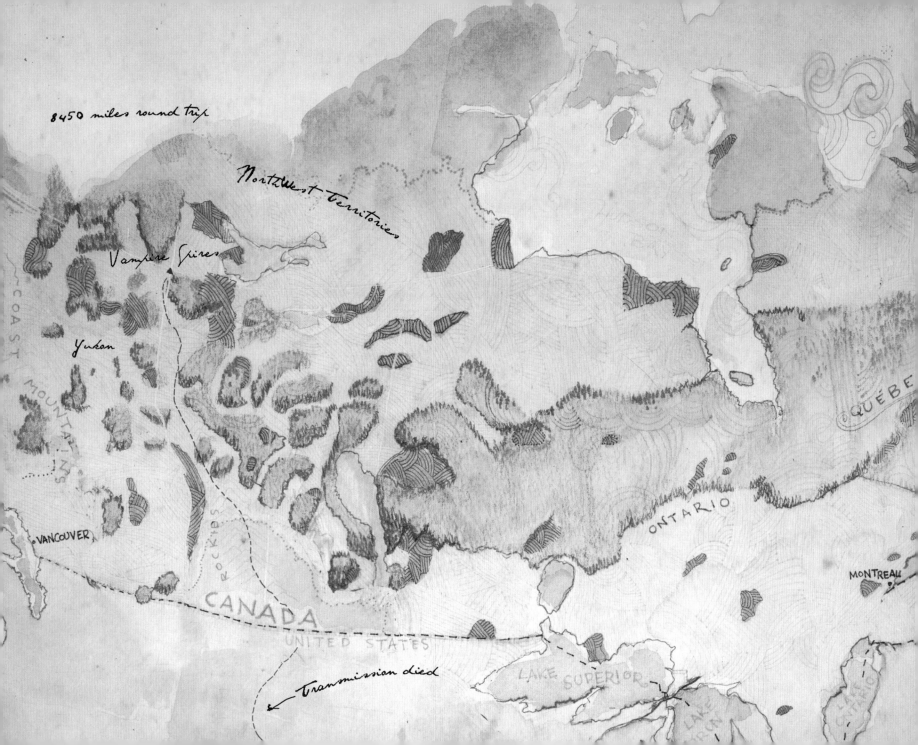

8450 miles round trip

Northwest Territories

Vampire Spires

Yukon

COAST MOUNTAINS

Rockies

VANCOUVER

CANADA

UNITED STATES

Transmission died

LAKE SUPERIOR

ONTARIO

QUÉBE

MONTREAL

LAKE
ONTARIO

"How long will you be gone?" Tricia asked.

"Probably no more than three weeks, maybe four."

"So you mean four, and maybe five, then."

She knew me well enough by now. The calendar in our house was where we met like opponents in a game of Battleship, plotting and scheming. It was scattered with red hash marks and exclamation points that demanded attention. Greens were important work dates; blue indicated school. Zion started kindergarten on August 12, but the latest the team could head north—my North—was August 8. Battleship sunk.

"I can't miss his first day of school, right?"

For me, school always felt like an obligation. Despite enjoying the social ingredient (a.k.a. the girls) and the creative challenges, I never felt like I fit in. Basically, when I was young, anything that I had to do wasn't a fit—church, brushing teeth, homework, algebra. Sociology felt like the most useful class I took, so I took it twice. Although my nostalgia for the first day of school wasn't quite as profound as my wife's, the team left without me to start the 125-mile journey down the South Nahani River in Canada.

The team this time is Pat Goodman, James Q Martin (a.k.a. Capital Q), me, and Jeff Achey (rhymes with "hockey"), a writer and climber from western Colorado. A sensei of rock, Jeff owns a good decade or more of experience than the rest of us. His reputation precedes him, and we each had an Achey story to tell of backing off or being intimidated by one of his early pioneered routes.

He tells us, "You guys won't believe this, but I have never been invited on an expedition before."

It is hard to believe, as Jeff was editor in chief at Climbing magazine for a number of years. He also has a key skill set to bring to the table: he's comfortable in the water, having recently paddled down the Colorado River through the Grand Canyon.

My three partners gathered in Watson Lake, population 800, to gather final supplies and fill their bellies with greasy burgers one last time. The South Nahani River traces the border of the Northwest Territories with the Yukon, in a roadless region just south of the Arctic Circle. From the put-in at the Little Nahani tributary, they planned to follow 125 serpentine miles through the Mackenzie Mountains on a raft to arrive at a drainage just before Broken Skull River.

Once there, 15 miles of dense, rugged forest would deliver them to our climbing rendezvous point, the paranoia-inducing peaks aptly named the Vampire Spires. Amid this twisted cirque of some 20 snowcapped summits lay the objective we came for, lured by a series of photos Pat had presented months earlier.

The Phoenix was one of the most beautiful walls I had ever seen, a crowned king in a valley of kings. It was rippled with parallel crack systems and had a cold blue north-facing aspect. Although the top of the 2,600-foot wall had been reached before, it had not in fact been free-climbed using just feet and hands for movement. This in and of itself was an immense attraction for us. But then Pat added to the allure: "And the wall is not even the top! It's only the beginning. From the top of the wall is a 2,000-foot ridge of snow and ice to an unclimbed summit."

That pretty much sealed the deal for me—for all of us, really.
Pat advertised it as "the last great un-freed wall in North America."

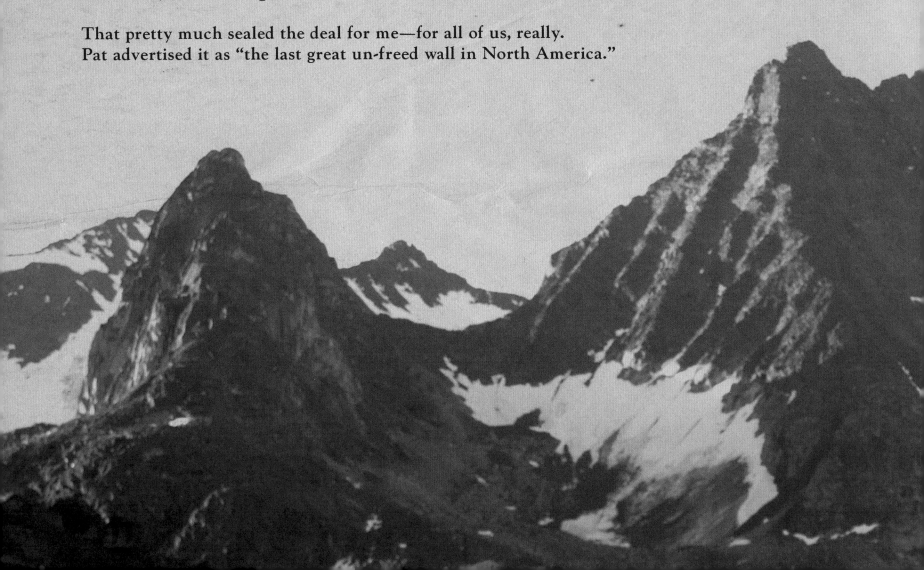

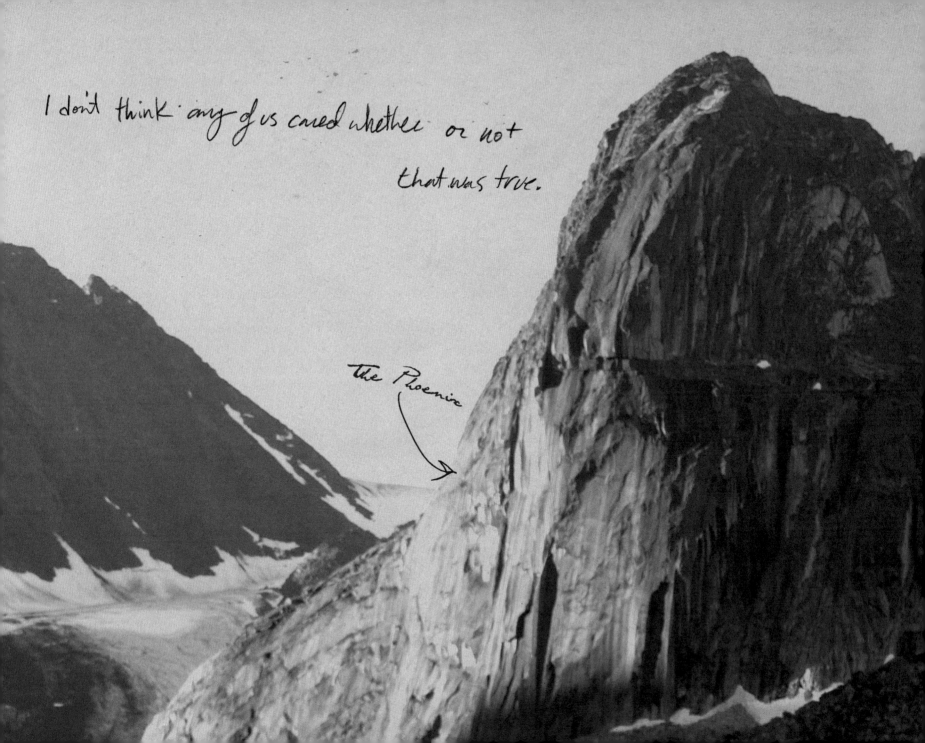

I don't think any of us cared whether or not that was true.

the Phoenix

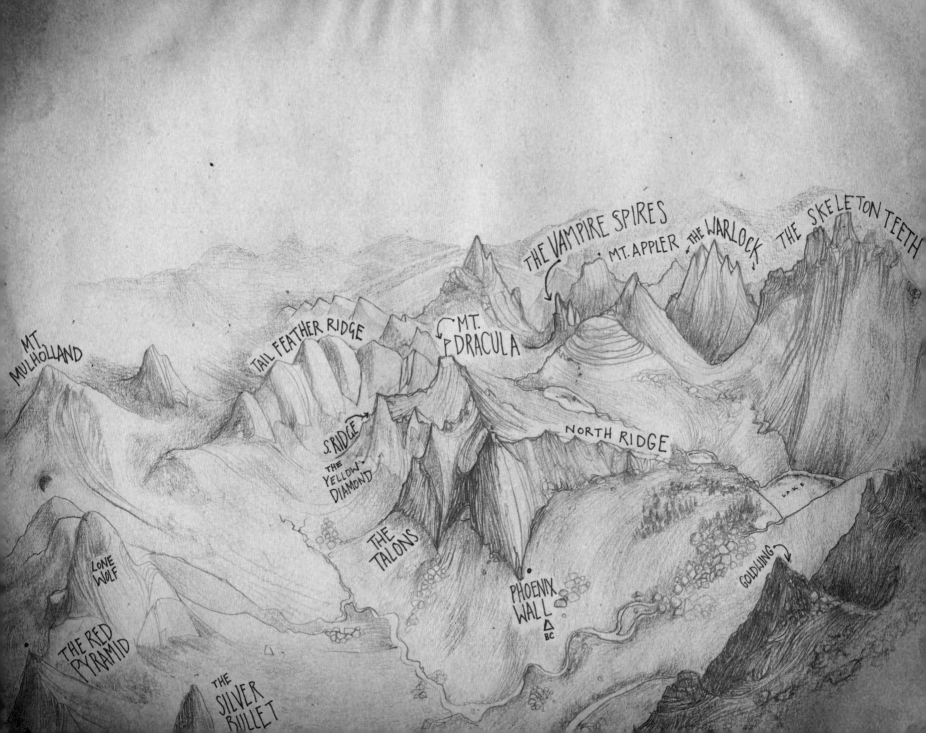

I arrived in our base camp in the Vampire Spires alone, one week later, delivered by a Hughes 500 helicopter from the remote Inconnu Fishing Lodge. Lodge owner Warren LaFave hires a helicopter pilot each summer to help deliver clients to the far reaches of the Mackenzies in the Ragged Range for fishing, climbing, or mining. Warren also pilots his 1979 de Havilland Beaver floatplane, landing in ponds, rivers, and alpine lakes with deft control and a sense of humor as rugged as the mountains themselves. Built stout, a chopped log of maple in blue jeans and a ball cap, he shook my hand as if swinging a hammer to pound a nail.

"Welcome to the Yukon, eh?"
I liked him immediately.

For 18 years he had run his lodge in the summer with his wife, Anita, flying in and landing on the lake with provisions and a new guest list. Warren had never been a climber, but he was the key holder to all the great climbs in the range, from the Cirque of the Unclimbables to Mount Proboscis and, farthest north, the Vampires. There are other ways to arrive that include extra driving, or river time as my team enjoyed, but for most, if you are planning a trip, you must talk with Warren first.

Helicopter pilot Bruce and I took off amid a light drizzle. He and his wife, Nancy, were retired, and were spending the summer flying, fishing, and enjoying being away from the world. He had a glowing white handlebar mustache that hung well below his chin, wore a pilot's jean jacket, and thought I'd brought too much stuff with me. Thirty minutes into the flight, he saw a storm developing ahead and landed in a large, open green valley on a tuft of grass.

"We'll stay here for a bit and See if the weather lets up," he said.

On all sides of us rose immense hills painted with yellow lupines, purple coneflowers, and an occasional explosion of a red flower I couldn't identify. High on the hilltops, clusters of spiked pines accented the angle of the rise. Snaking through the valley was a scribbled stream never wider than 10 feet, offering a rippled song as sweet as a violin. Wrens flitted in the brush, and the ground was moist from rain.

We disembarked, and Bruce showed me to a small, ramshackle log cabin no bigger than a van, hidden behind some gnarled trees. Outside was a pile of wood as tall as I was. Moss grew over the roof like a wool hat. Inside was a hand-cut wood cot, a spoon, a bowl, some candles, and matches.

"This is my gas outpost," Bruce said.

"I store gas here for emergencies or whenever my fuel gets low. Every once in awhile I drop a hunter here for a week."

Then he took me out behind the cabin on a elevated rise of clover and groundcover.

"Last week I flew by here and saw a grizzly bigger than the shack out back. Sure enough! Look here. She rooted up these berries and clawed at the cabin. She must have been looking for a snack. Glad it wasn't me."

Suddenly the helicopter felt very far away, and the knife on my belt felt like a soggy used toothpick. I helped Bruce restack a fallen portion of the woodpile and top off his gas tank. Then the weather cleared, and we headed toward the Phoenix.

Flying into the valley of the Vampire Spires, as the nose of the chopper banked eastward, we passed a large male caribou on the spine of a snow-covered ridge. Mountains rose violently all around us, like waves in a great storm where we bobbed and dipped into the deep of it.

And then there it was - The Phoenix - massive and singular, divine and terrible all at once.

It was 4 p.m., and the skies were swirling with dark clouds. The rain was present and bearable, but threatening worse. I unpacked the chopper, and 20 seconds later Bruce was gone.

I was alone in the Great White North.

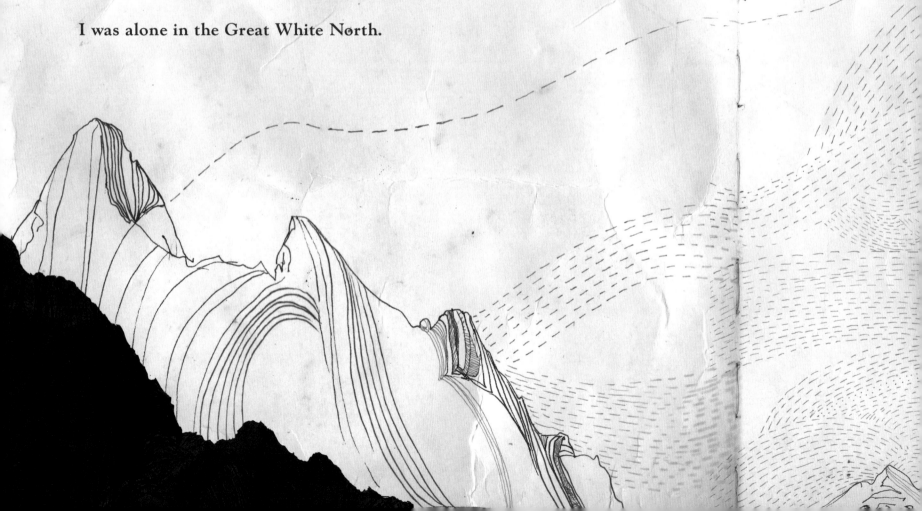

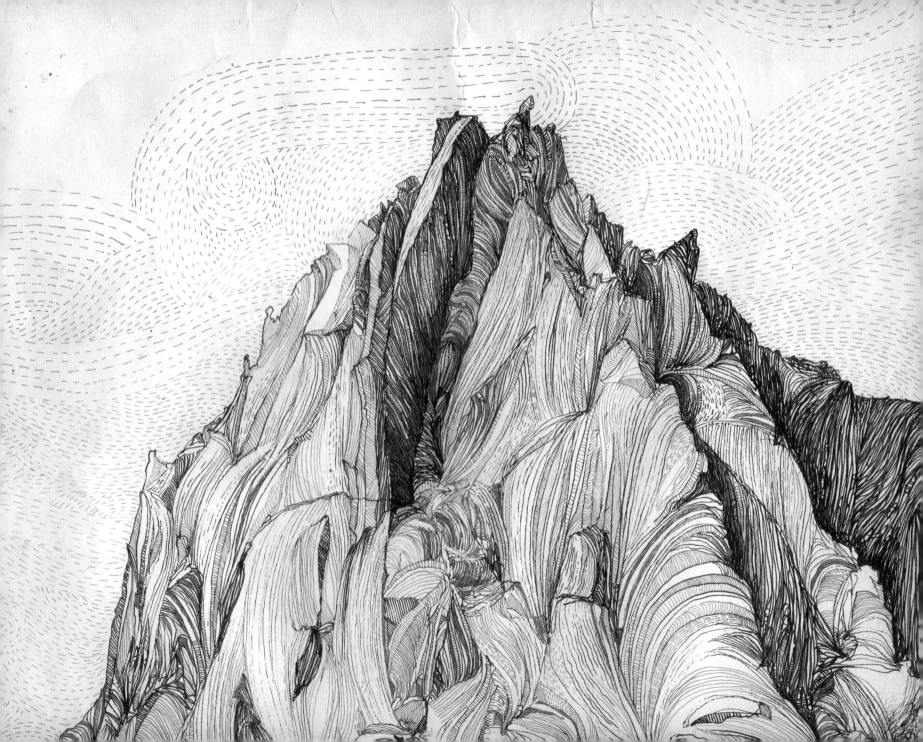

I sprang into action, building a base camp before the rest of the team arrived at our rendezvous. We had decided that Bruce would fly to the river and pick up Pat, Q, and Jeff so they could avoid the storm-filled 15-mile hike up the drainage. In minutes I had the two sleeping tents and a large cooking tent erected. As the rain intensified, I shuttled climbing gear and food into tents. I then took stock of where I was. Snowcapped summits peeked from behind ridges. Boulders of all sizes were piled in clusters across the valley, their faces painted with bright green and red lichen. The faint hiss of a waterfall wafted from up canyon, and a creek wove in and out of dense hummocks of grass.

All around my feet were deeply imprinted elk hoofprints and scat.

A variety of flowers scribbled color into the blue alpine environment, and through my binoculars I could see a family of shining white mountain goats perched in a cave a thousand feet above. I pulled out my sketchbook, curled up under my umbrella, and sat down to draw. But the familiar womp-womp-womp of the helicopter sounded from over a ridge before I could make a single mark.

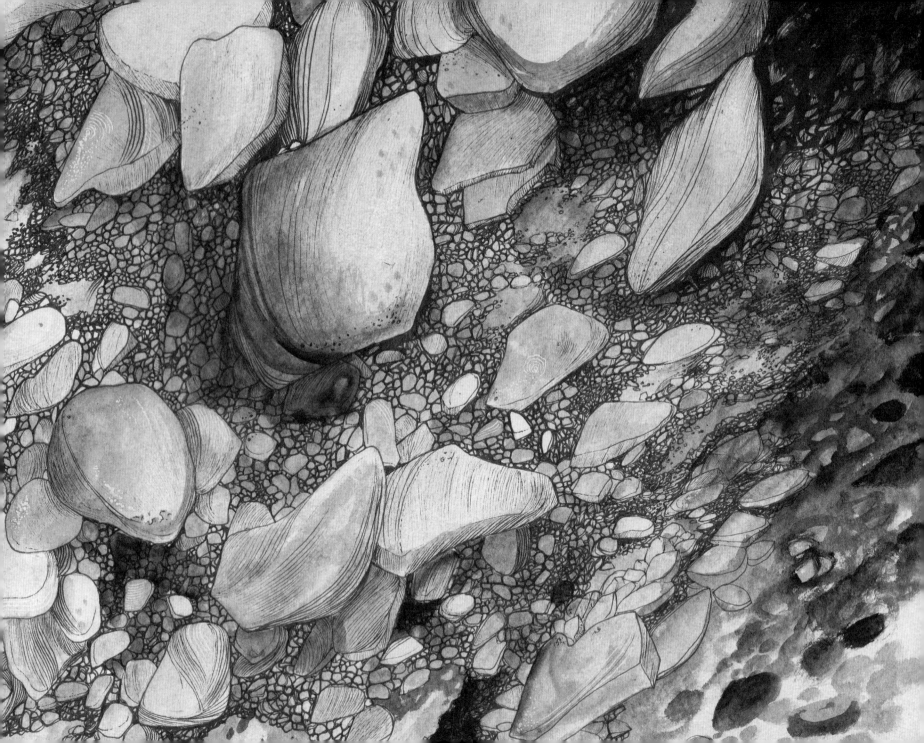

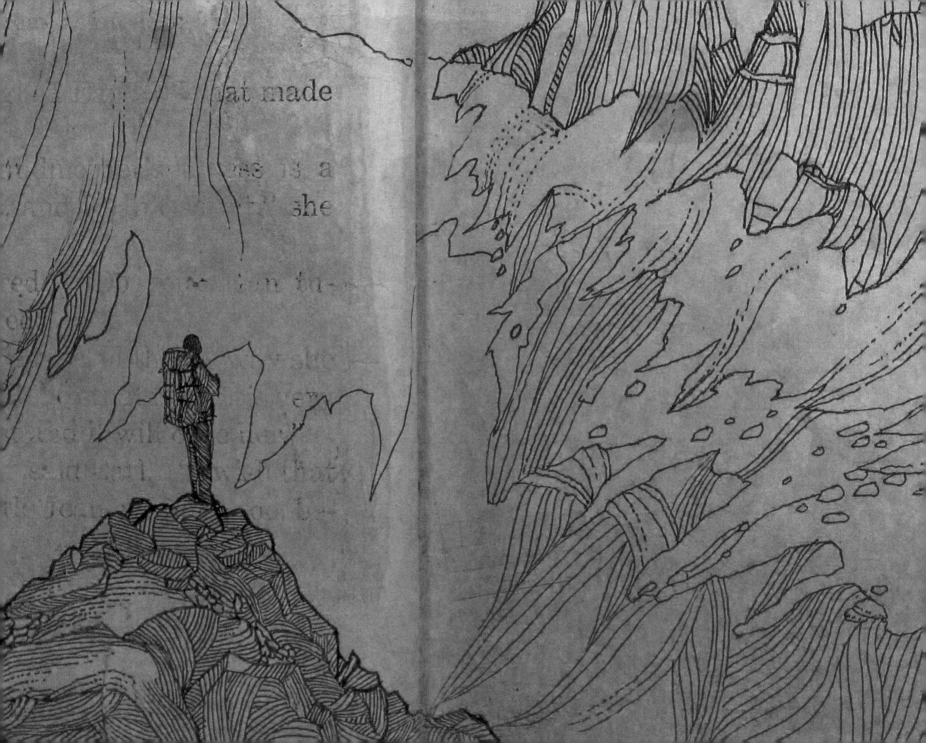

Jeff, Q, and Pat spilled out with their river gear, and we all exploded into hugs, beers, and stories. Their sunburnt faces and toothy smiles were a sight for sore eyes. Jeff and I had never met in person before, and we enjoyed the bizarre circumstances of greeting each other for the first time in this strange place. Bruce had quickly piloted out again, racing the weather and disappearing, a faint blue dot in the storm.

With a high-pressure system promised, we quickly launched up the wall in the morning, collectively soloing 200 feet of low-angle wet rock that gradually became steeper, until I stood on a gravel- and grass-covered perch 30 feet above Jeff with the valley spread out beneath my heels.

"It's probably time to use all this gear we hauled down here, huh?" I called down.

"I'm for it," Jeff replied.

I tied in to the rope and began leading upward, toward the base of the main pillar of the Phoenix Wall.

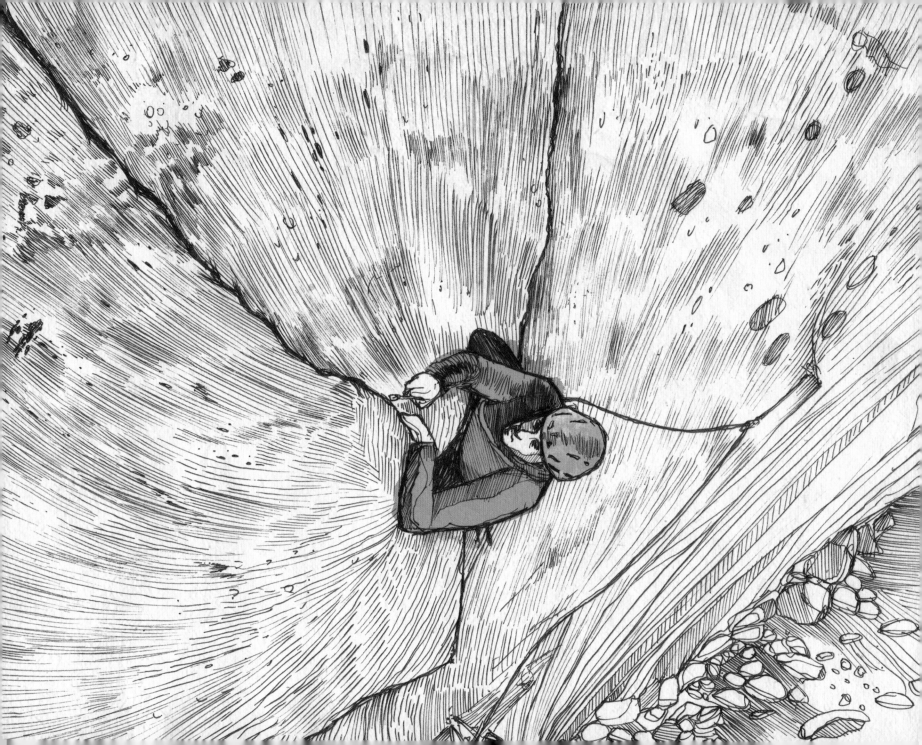

Immediately the climbing difficulty escalated, and I was glad to have the rope. I built an anchor and began to bring up Jeff, while he dragged up a second rope for Q and Pat.

Jeff took the next lead and showed the skill he had honed during 30 years of clawing up rocks, methodically moving through steepening stone, removing the occasional loose block while maintaining calm breath and body language throughout. At 54 years old, he was looking for diversity in his activities; while still climbing, he had taken up soo bahk do, an ancient martial art from Korea, and was close to achieving his black belt.

I took over in a shallow left-leaning corner with a slight opening in the back.
I plugged in some protective gear and stood up on some popcorn-size knobs.
My fingertips just barely fit into the crack, not even to the first knuckle.
I took a deep breath and moved again, my calves straining from the pressure.
I worked the tips of my fingers higher, but not any deeper into the seam.

I placed another piece of gear and dipped into my chalk bag.

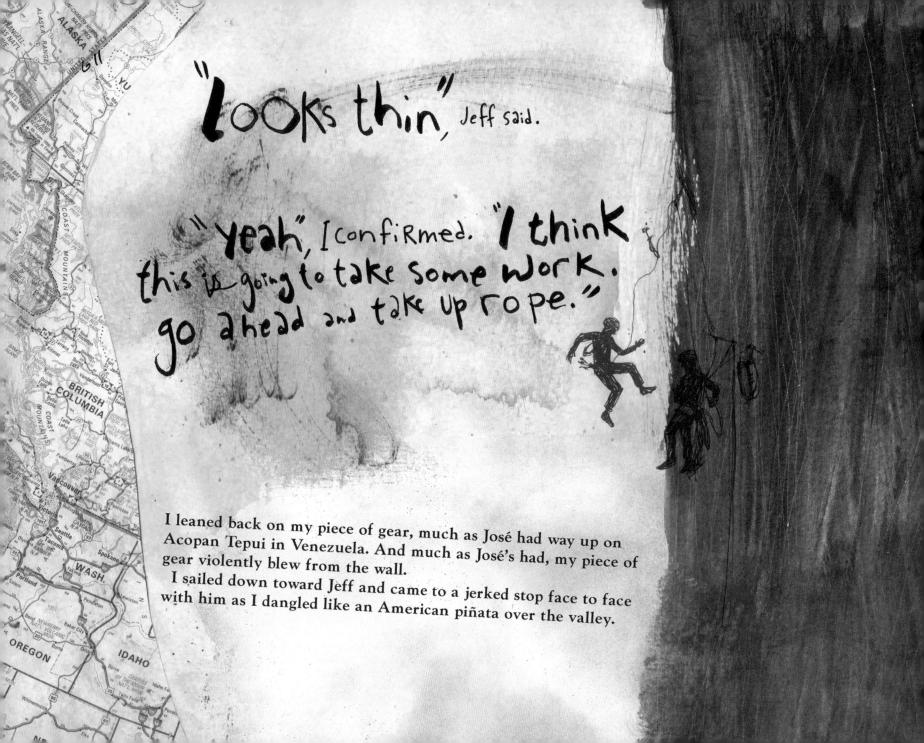

"Looks thin", Jeff said.

"yeah", I confirmed. "I think this is going to take some work. go ahead and take up rope."

I leaned back on my piece of gear, much as José had way up on Acopan Tepui in Venezuela. And much as José's had, my piece of gear violently blew from the wall.

I sailed down toward Jeff and came to a jerked stop face to face with him as I dangled like an American piñata over the valley.

"oh, hey buddy," I said.

"Hey Man. How's about Some lunch?"

Quite a way to start a new climbing partnership.

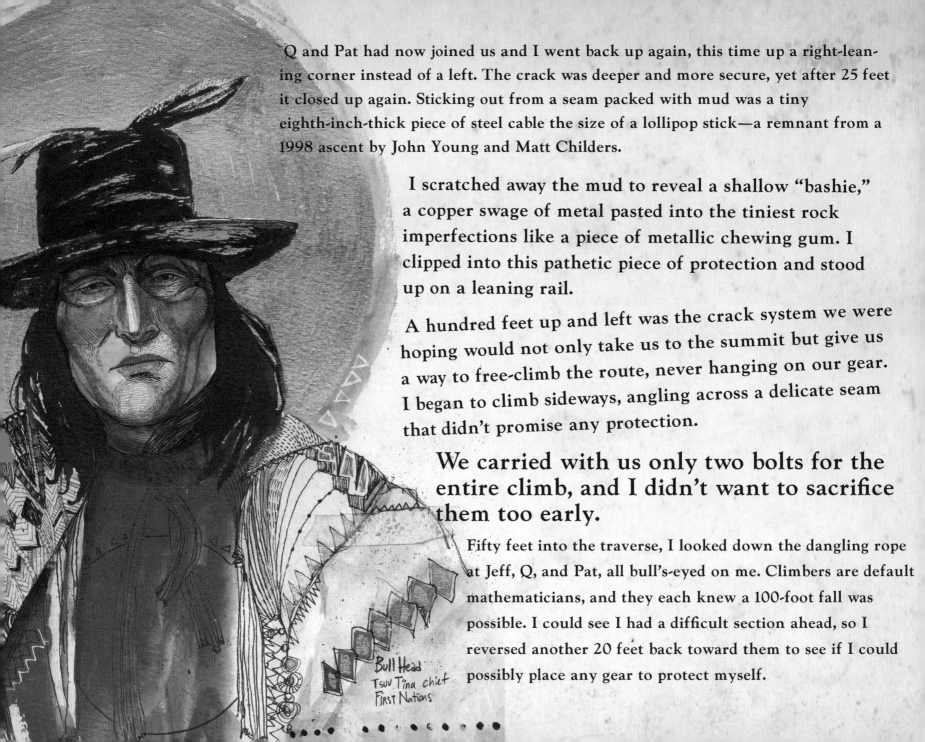

Q and Pat had now joined us and I went back up again, this time up a right-leaning corner instead of a left. The crack was deeper and more secure, yet after 25 feet it closed up again. Sticking out from a seam packed with mud was a tiny eighth-inch-thick piece of steel cable the size of a lollipop stick—a remnant from a 1998 ascent by John Young and Matt Childers.

I scratched away the mud to reveal a shallow "bashie," a copper swage of metal pasted into the tiniest rock imperfections like a piece of metallic chewing gum. I clipped into this pathetic piece of protection and stood up on a leaning rail.

A hundred feet up and left was the crack system we were hoping would not only take us to the summit but give us a way to free-climb the route, never hanging on our gear. I began to climb sideways, angling across a delicate seam that didn't promise any protection.

We carried with us only two bolts for the entire climb, and I didn't want to sacrifice them too early.

Fifty feet into the traverse, I looked down the dangling rope at Jeff, Q, and Pat, all bull's-eyed on me. Climbers are default mathematicians, and they each knew a 100-foot fall was possible. I could see I had a difficult section ahead, so I reversed another 20 feet back toward them to see if I could possibly place any gear to protect myself.

Bull Head
Tsuu T'ina chief
First Nations

Beneath my feet, ancient lichen and granules of rock groaned and released into the air, blown back upward by the soaring mountain winds. I scanned every seam and fissure looking for any possibility of an opening for gear. My right hand curled over a crunchy edge, four inches wide by a half inch deep. On its back side, a small postage stamp–sized seam packed with mud and moss invited some inspection. I dug into it with a knifeblade–thin piton. Without the moss, the promise of a placement of protection was revealed.

"Yes," I hissed through clenched teeth. I drove the three-inch piton in with four swings of the hammer, as if this tiny opening on the mountain had been waiting eons for its visit. I clipped my rope to it and continued across the traverse, eventually ending at another small ledge. We had reached the central corner system that would potentially lead to the summit. The biggest question had been answered.

It began to rain, so we pulled on our jackets and rappelled the 500 feet back to base camp for some soup and tea. The rain held on through the night and the next day, so we took a break from the climb and busied ourselves around camp.

I found a spot in the valley surrounded by wildflowers, offering some interesting perspective for drawing.

Q and Pat meandered the valley, climbing boulders and wandering through mazes of stone. Jeff went on an exploratory hike that launched with

"BACK IN A FEW HOURS, GUYS. I HAVE A RADIO AND AN ICE AX."

The hours trickled by as I disappeared into lines and shapes.

A day of drawing, for me, is just as satisfying as a beautiful climb.

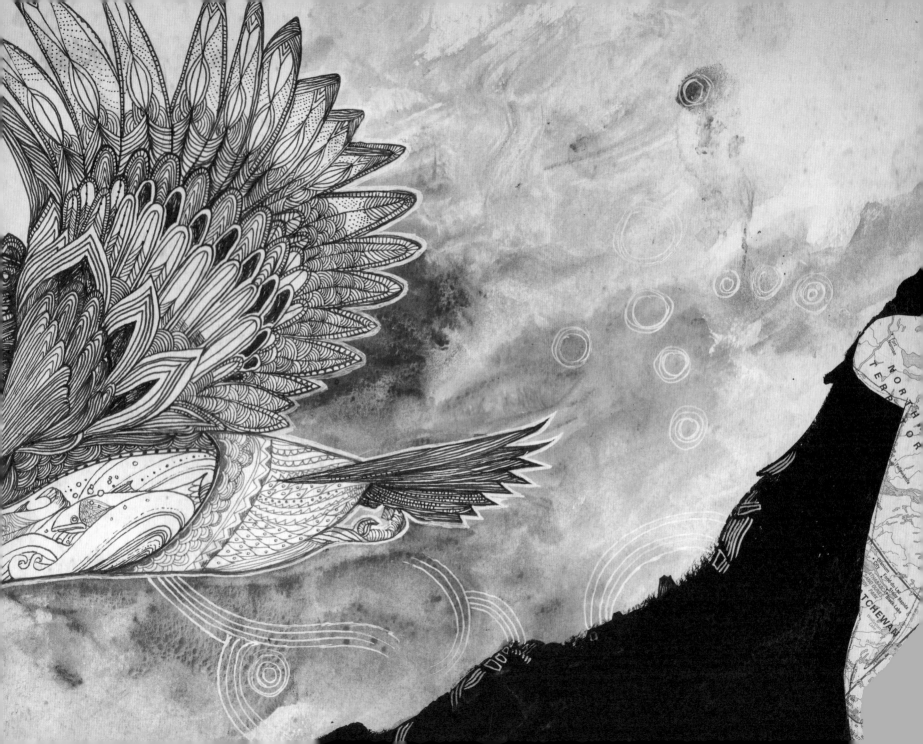

As the sun began to prepare for bed, the clouds finally lifted. Q, Pat, and I sat around a small fire, making a dinner of freeze-dried potatoes, eggs, and beans. Jeff had not yet returned. We peered through our binoculars in the direction he had wandered—a zigzagged glacier winding up and eastward into a trio of immense peaks of rock and snow. One was red, one black, and one grey.

I was concerned for Jeff, but sympathetic too. A brief solo adventure, after a week on the river with the team, was likely cathartic.

After another hour, we heard the *tack-click-tack-click* of fast-moving trekking poles striking granite. Jeff was back, breathing heavy, and had stripped down to the bare essentials despite the cold air. He had a wide grin, a red nose, and a renewed brightness in his eyes. He had been on a soul journey.

"What'd you do today, hockey puck?" Q started.

"I climbed that."

Jeff pointed to the highest peak on the northeastern end of the valley, a steep pyramid of shattered red rock and snow rising on the horizon, maybe 4,000 feet higher than the valley.

"I took the northern Couloir up left over the shoulder behind the grey peak, then hit patches of ice on the north face as I got higher. All of a sudden, I was on the summit. It was amazing."

FINLAYSON LAKE
CARIBOU ANTLER

We marveled at the productive day of the "old guy" and watched the last kiss of sun say goodnight to the red summit, imagining a tiny Jeff up on top alone.

He continued his story.

"I followed some Caribou tracks in the snow over the pass. The higher I got, the more refined the prints. Then I realized... I wasn't following Caribou tracks."

He turned his camera's LCD screen toward us to reveal:

"It was a Wolf."

Sure enough, the prints were as big as his open hand, deep and sharp in the crusted snow. Were we being watched?

I zipped the tent closed and struggled to fall asleep, listening to the gurgled song of the creek outside.

Nighttime is when I miss my family the most.

Living in a love paradox means accepting these moments of loneliness and embracing the fear that comes with them. In the dark I doubted my reasons for being here.
Was it for me?
Was it for Jonny?

Visions of Tricia lying in bed alone swirled in my dream-ridden head. I awoke with a start.

I went out into the cold, and what awaited me outside defies description....

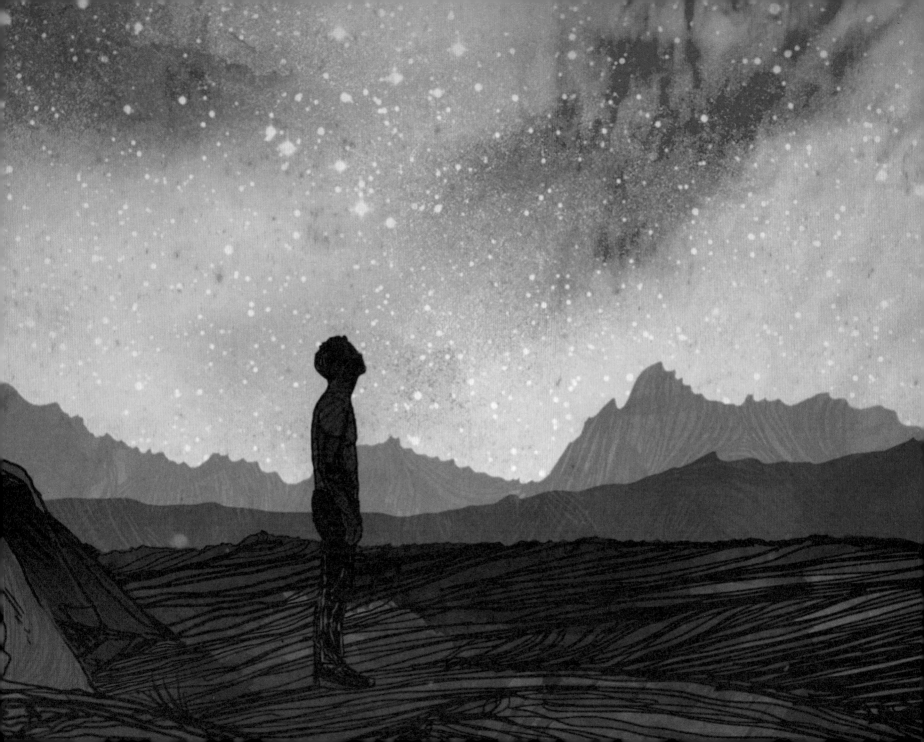

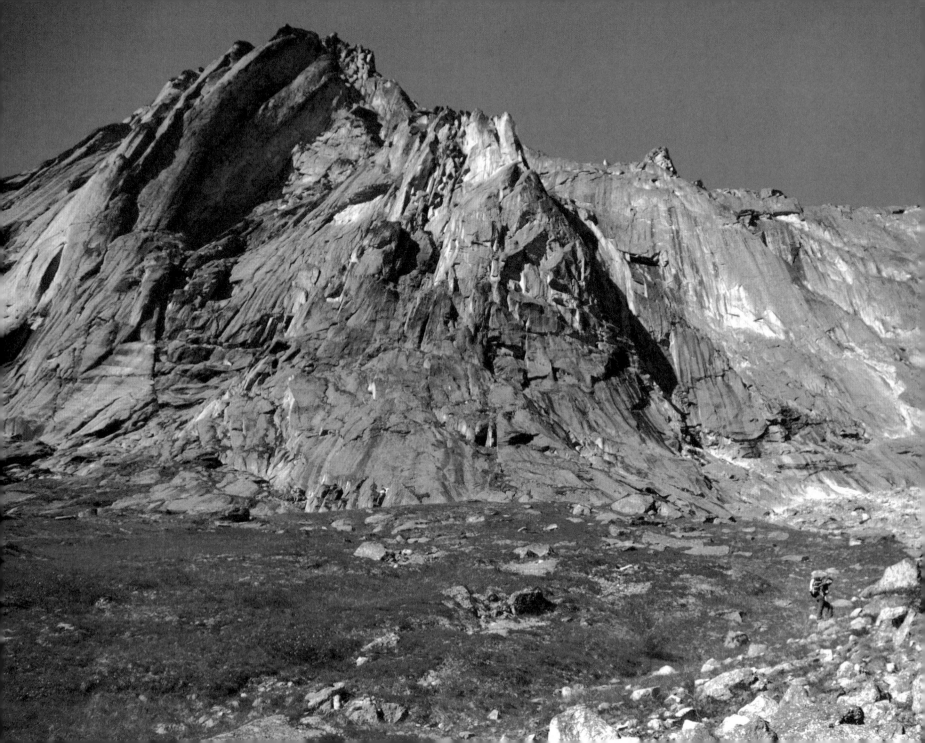

Morning came quick and clear,

but the mountain was still soaking wet, with water streaming from the cracks we intended to climb. Stir-crazy Jeff decided to reascend the ropes to our high point to deliver haul bags with food, water, and sleeping gear. We planned to launch for the summit the next day whether the wall was dry or not. The rest of us readied the gear to commit to the climb.

We started from base camp before dawn, under a splatter-painted sky of stars:
first Jeff, then Q, Pat, and finally me.

By the time I arrived at the base for my turn to climb, the sunrise was shimmering off the remaining water stains and puddles around me. The temperature shifted and I began to climb solo up the opening corners, roughly 150 feet of technical climbing, no harder than 5.8 at any point—easy in comparison to what was ahead. The moves felt casual and welcome, as it was now my fourth time starting up the wall. It was good to get a tent-bound body awake.

A hundred feet up, just before the first horizontal break, a foothold broke from beneath the weight of my left boot and I growled like a threatened animal. I rolled out of my stemming stance and my fingers clawed at the rock as I started fighting for purchase in a downward slide.

Nothing went through my mind but survival and short-term memory—that
of a ledge I had mantled past eight feet below. Brain synapses fired and I
knew if anything, this would be a place I could aim for.

Gravel that spends the majority of the year entombed in ice scattered around me, and as soon as it began, it was over. I stuck the ledge.

Halted there on a heaven-sent perch, I again thought of home: Zion playing soccer, baby Sela on a swing set, and Tricia bounding ahead of me on a trail run, colorful autumn leaves kicked up with her every step, golden October sun streaming through trees in fingered rays.

I told myself,
You chose to be here.

I waited for my breathing to calm. From my elbow a stream of blood exposed the roughness of the fall. I pulled my underwear layer over it, took a deep cleansing breath, and began to climb with a renewed focus. I arrived at the high point and made no mention of my mishap.

No one had seen my fall.

Above, Pat was pushing the rope upward, transitioning from crack to crack, aiming toward an immense corner above. After a couple dead ends into blank rock, he found the way, and Jeff took over to finish another 500-foot day with a spectacular lead of the Dixie Corner, over 120 feet high, starting at eight inches wide and finishing just barely big enough for a finger. Despite consistent difficulties, we had pieced together a way through the maze of cracks.

Our confidence was high that we had found the free line up the wall.

At sunset, Jeff announced over the radio that he had found a suitable ledge up above, and we all joined him as quickly as possible. Around us a silent mist settled in. Mist turned to rain, then rain turned to snow. Assembled under a tarp, we made tea with our stove. Our lodging for the night was a series of terraces pasted to the wall in a clump. Each was five to six feet wide and roughly two feet deep, likely the only place for a night's sleep in the last 1,000 feet of climbing.

Dinner was utilitarian as the snow swirled around our headlamps and began to pile up. It was warm enough that it melted quickly, making everything wet, including our attitudes. I rappelled 60 feet below to a ledge I had spotted on the way up. It was a pitiful destination, but there I was.

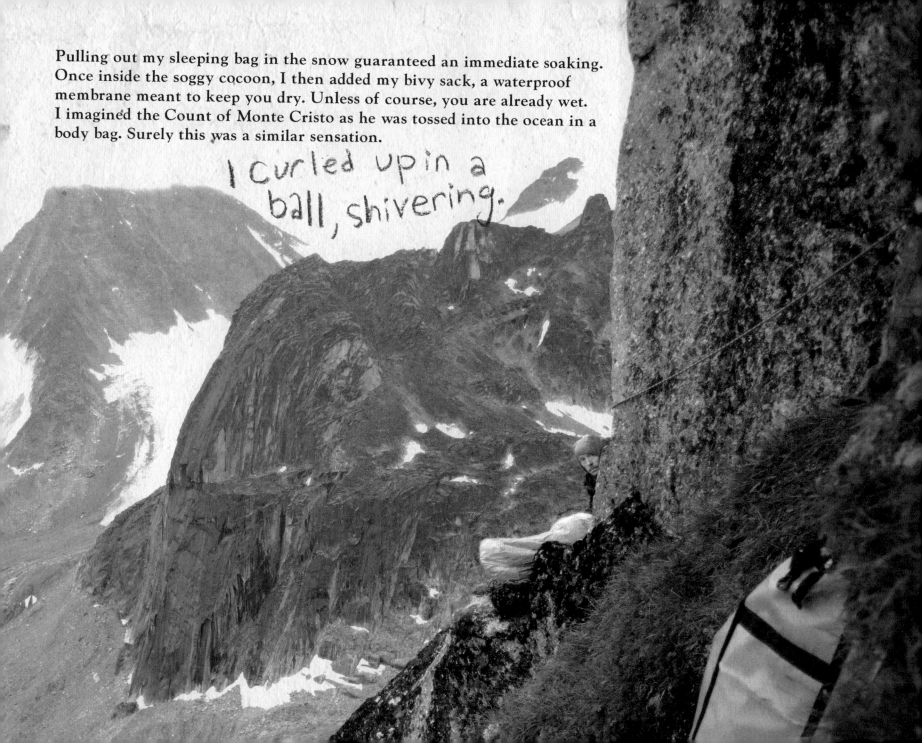

Pulling out my sleeping bag in the snow guaranteed an immediate soaking. Once inside the soggy cocoon, I then added my bivy sack, a waterproof membrane meant to keep you dry. Unless of course, you are already wet. I imagined the Count of Monte Cristo as he was tossed into the ocean in a body bag. Surely this was a similar sensation.

I curled up in a ball, shivering.

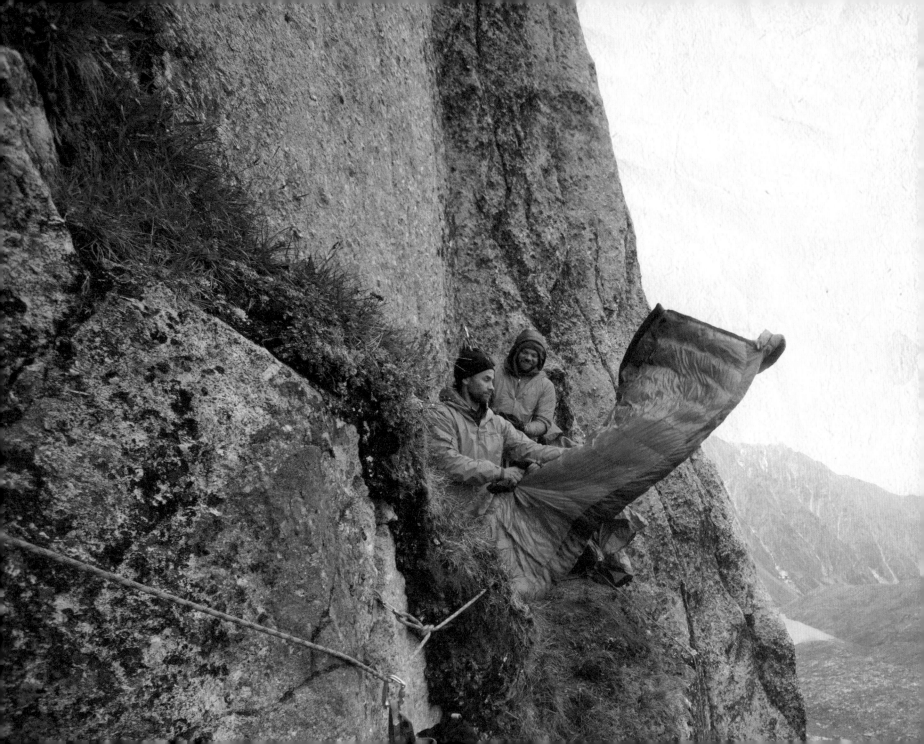

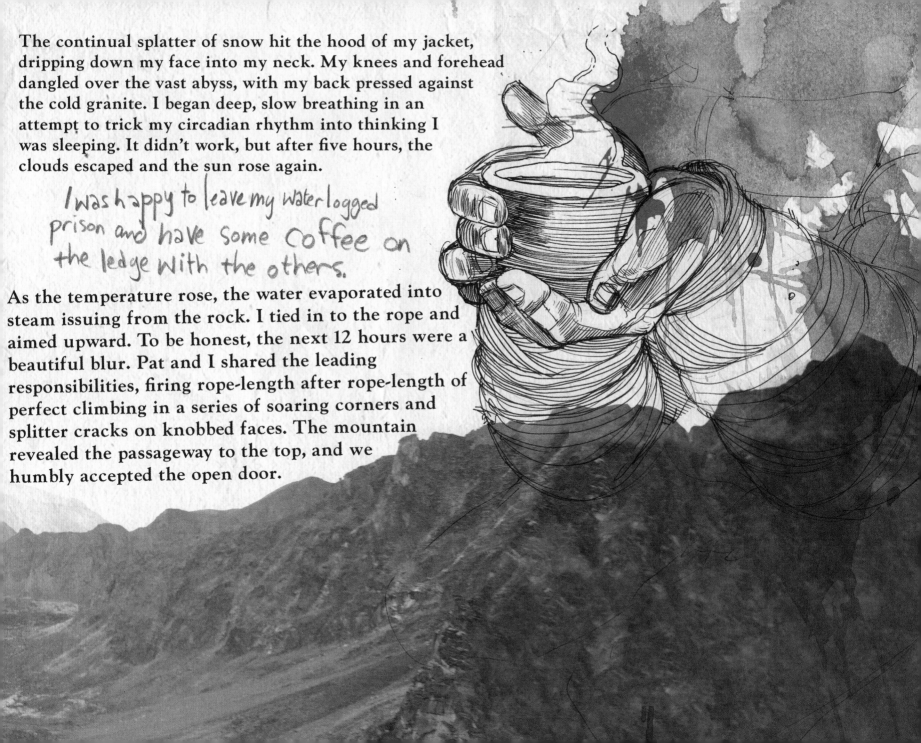

The continual splatter of snow hit the hood of my jacket, dripping down my face into my neck. My knees and forehead dangled over the vast abyss, with my back pressed against the cold granite. I began deep, slow breathing in an attempt to trick my circadian rhythm into thinking I was sleeping. It didn't work, but after five hours, the clouds escaped and the sun rose again.

I was happy to leave my waterlogged prison and have some coffee on the ledge with the others.

As the temperature rose, the water evaporated into steam issuing from the rock. I tied in to the rope and aimed upward. To be honest, the next 12 hours were a beautiful blur. Pat and I shared the leading responsibilities, firing rope-length after rope-length of perfect climbing in a series of soaring corners and splitter cracks on knobbed faces. The mountain revealed the passageway to the top, and we humbly accepted the open door.

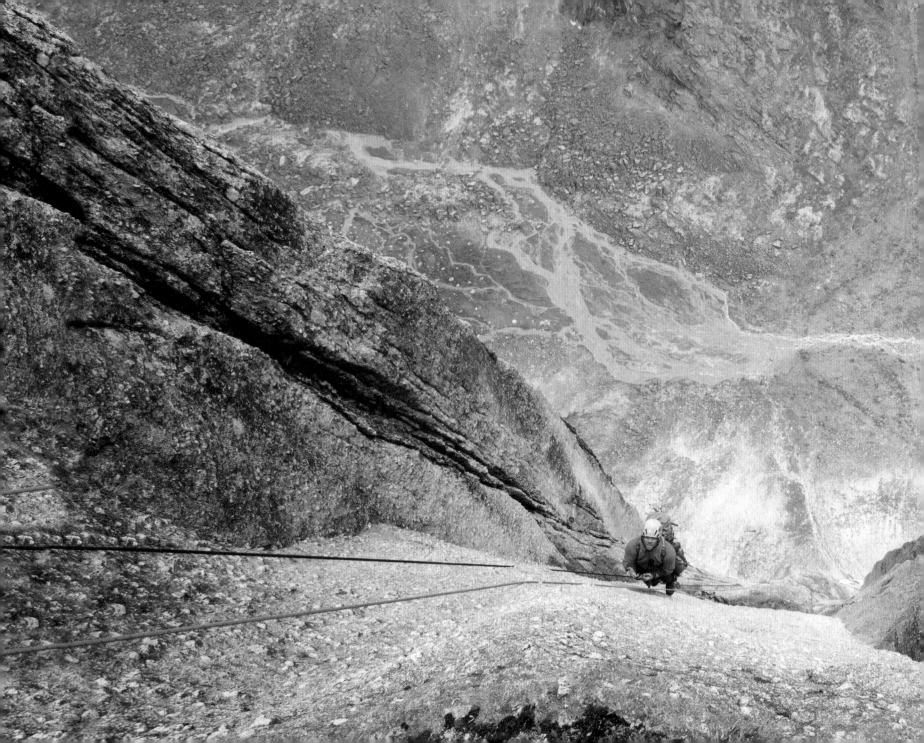

By the seventh full rope-length off our soaked lodging, we were cautiously optimistic that we could go for the summit. It was here that I ran into the roof. Legs stemmed at max capacity, I stood 50 feet from my last protection with a gaping ice-filled chimney beneath me and above me the 40-foot roof tapered to a squeeze. I had no idea whether or not I would fit into it.

The ice radiated cold, and again all eyes were on me from below.

Jeff offered a "you got this, dude!"

I committed.

Inside, dribbles of ice and water lined the walls.

Delicately placing each foot exactly where it should go, I ascended into the darkness.

I inched farther and farther from my sole protection as visions from yesterday morning's fall threatened to invade my mind.

Inhale. Exhale. Upward.

We had only one wide piece of gear, and that was the only piece between me and the belay. Now my protection was a quiet mind and precise movement.

I thrutched as delicately as I could into the squeeze, first at 13 inches wide, then tighter. My chest and back pressed into the rock, and for a moment my feet dangled over the void. Once you've committed to the direction you face, you stay that way, as there is no room to turn your head in the opposite direction. I chose to look outward, into the valley.

And then ... I laughed. I cackled, really. Then I howled like a wolf: "AWHOooo..!"

Jeff gripped the rope below, wide-eyed. Has he gone mad? Is he going to jump?

I bellowed down, "There's a finger crack inside the squeeze!"

Protection. With a wide grin on my face I journeyed into the wall, working knee, heel, toe, butt, and belly in an orchestrated squirm upward.

Eighty feet later I popped out onto a ledge, still laughing, so happy to arrive. Above, against the sky, I could see the top of the wall. My body was tired, but my soul was wide awake. The clouds moved in again, and we moved fast, arriving one by one to a pointed beak of granite overlooking the valley, 19 pitches and roughly 3,000 feet above our base camp. We repacked our ropes, changed from rock shoes into boots, hung our axes and crampons on our harnesses, and started out on the ridge to the summit.

The Phoenix 5.11 - 18 pitches

PITCH 1 - (5th class scramble up angling corner to perch
2 - (5.8) R mossy, grassy corner to the left of belay/Rap anchors - take to upper bowl/terrace
3 - Right most of 2 corners. good Rock passes through 2 Roofs. Stop at R leaning corner
(.10c)
4 - (.10 R) Right leaning corner leads past pin and fixed head. At horizontal break, head left on Rising ledges, passing a pin. Stop beneath dihedrals
5 - (10+) Up flakes and corner until a small flake on the left can be Reached. traverse left under a bolt. Up past the bolt into a shallow groove (10+) leads to a splitter finger and hand crack on the left. After 35 ft. of this, end in an alcove.
6 - 10+ leave alcove on left, under clinging a Roof. follow left facing corner to anchor or ledge
7 - 9+/10- traverse across creaking jugged ledge on loose blocks. downclimb a pile, passing a grassy crack, eventually arriving at a cleaner handcrack.
8 - (11) follow the hand crack to bolt. traverse left on blank face to transition around buttress into finger crack that continually widens to offwidth
9 - (10) "The Dixie Crystal corner" perfect corner, 10" to 1"
10 - (10) follows corners up to ledge. grass happens.
11 - (10+) exit ledge on Right, via steep hand cracks. Avoid exiting Right on black Rock and Stay in the steep corner. Exit into immaculate corner. traverse Right to ledge under the "Twin Splitters"
*12 - O follow twin cracks through loose system on left (original). after Roof follow splitter to narrow ledge with anchor
13 - (10) traverse Right across slab, aiming towards huge chimney. despite appearances, this is protectable with a standard Rack. belay on large grassy ledge.
*14 - (8) wander up multiple corners Roughly in a trough/chimney system until it gets disgusting, belay out Right on a perch

18 pitches, 2600 feet

15 - (10) angle up and Right on a perfect finger crack on a slab until hitting a grassy corner. this leads into a short chimney and squeeze TIGHT!
16 - (7) traverse left above the Roof and scramble up a immense black boulder. Belay up beneath the summit wall and left in a huge cross pin. Belay on a wide terrace
17 - (9) angle Right across cross slab towards corner system p...
18 - (9) continue up broken corners. Path of least class and Resistance

Ahead of us, the clouds eddied in a fantastic show, with the sun radiating from behind in an ethereal glow. Spiked pillars and gendarmes of rocks along the ridgeline appeared and disappeared in an instant, like shadow figures in a haunted house. What we anticipated would be ice turned out to be easy snow. What we anticipated being snow was solid rock.

Occasional fifth-class sections went quickly despite tremendous exposure. Some 2,000 feet of air spilled beneath our heels along the ridge. The mountain once more showed us the way. In an hour we had arrived together at what we thought to be the summit, a flat pedestal of stone uniform on all sides and prominent on the ridge.

Then, like the curtains on a stage play, the swirling clouds pulled away, revealing the entire range to us. We were indeed on top of the mountain, and I was on top of the world. As far as we knew, no one had ever been here before.

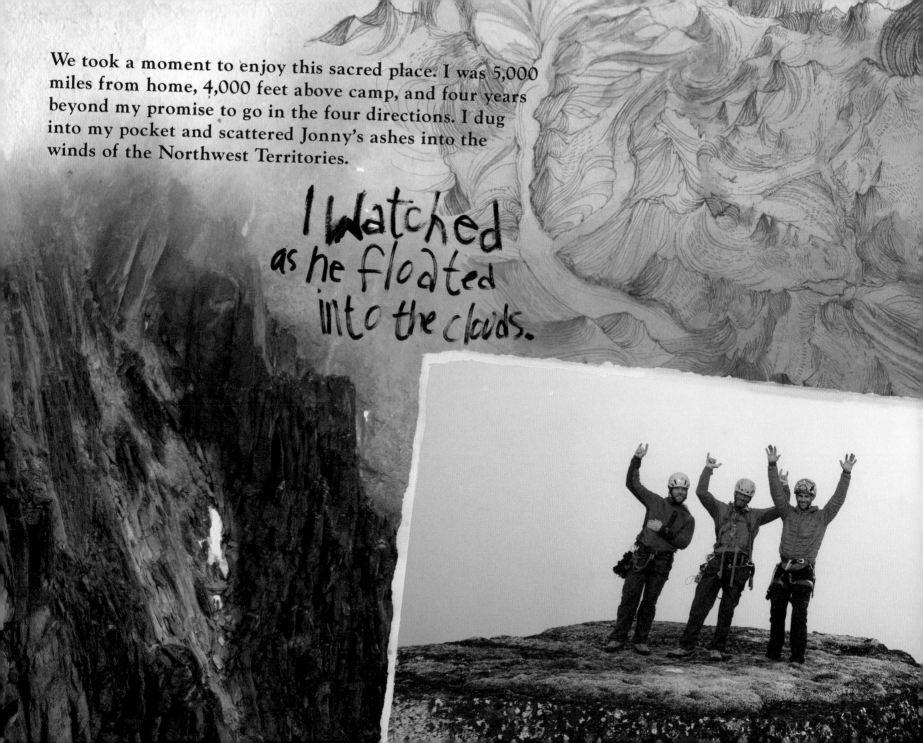

We took a moment to enjoy this sacred place. I was 5,000 miles from home, 4,000 feet above camp, and four years beyond my promise to go in the four directions. I dug into my pocket and scattered Jonny's ashes into the winds of the Northwest Territories.

I watched as he floated into the clouds.

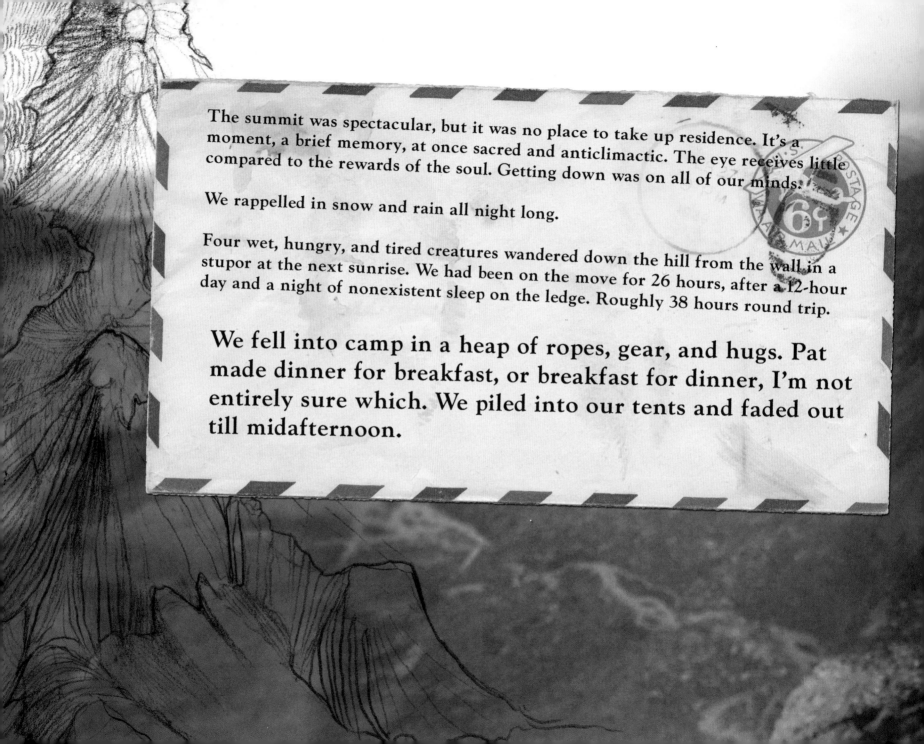

The summit was spectacular, but it was no place to take up residence. It's a moment, a brief memory, at once sacred and anticlimactic. The eye receives little compared to the rewards of the soul. Getting down was on all of our minds.

We rappelled in snow and rain all night long.

Four wet, hungry, and tired creatures wandered down the hill from the wall in a stupor at the next sunrise. We had been on the move for 26 hours, after a 12-hour day and a night of nonexistent sleep on the ledge. Roughly 38 hours round trip.

We fell into camp in a heap of ropes, gear, and hugs. Pat made dinner for breakfast, or breakfast for dinner, I'm not entirely sure which. We piled into our tents and faded out till midafternoon.

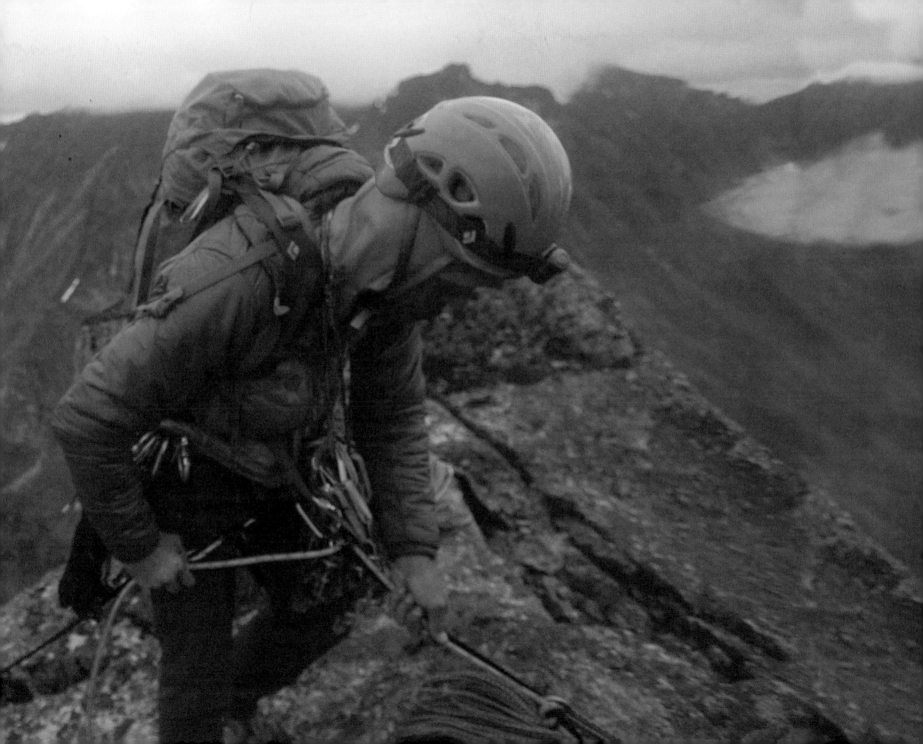

CHAPTER 5:

Being Drawn

" *Even as individuals, we seem to have a need to plot a path and track our progress, to imagine possibilities of exploration and escape. The language of maps is integral to our lives, too. We have achieved something if we have put ourselves (or our town) on the map. The organized among us have things neatly mapped out. We need compass points or we lose our bearings. We orient ourselves. We give someone a degree of latitude to roam.* "

Simon Garfield
On the Map

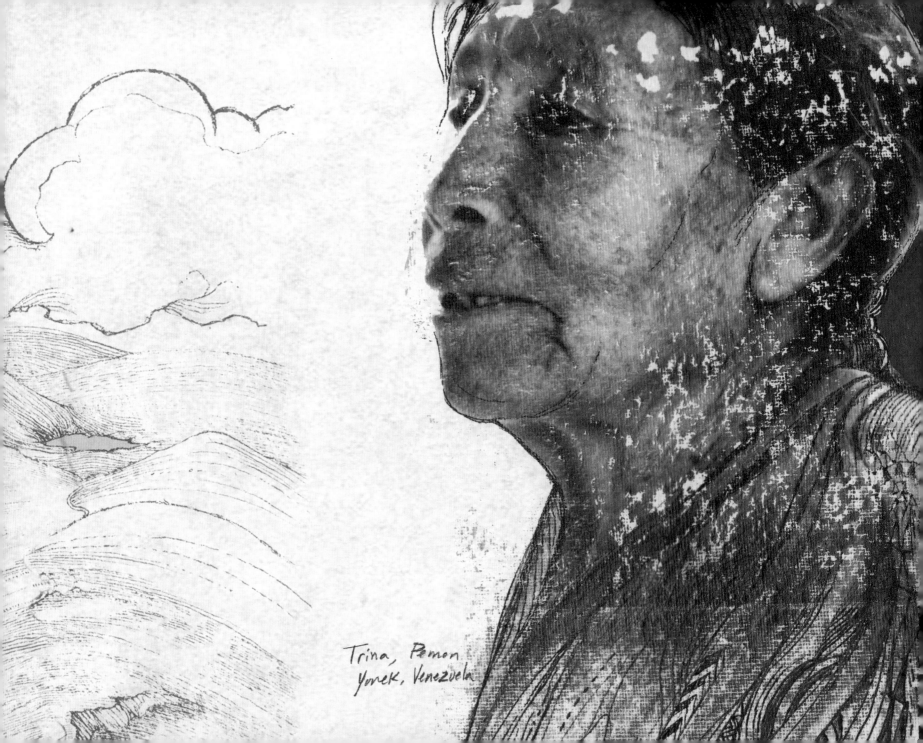

Trina, Pemon
Yonek, Venezuela

Six months later, Pat, Capital Q, José Miranda, and I loaded into the Tank again. We had come back to finish what we started in the jungle, and now found ourselves stuck for four days in the same Ciudad Bolívar hotel as the previous year. With illegal mining activity in the area ever increasing, a group of Pemons from the nearby village of Uriman had taken matters into their own hands—by capturing about 40 Venezuelan soldiers and taking them hostage. The Pemons claimed the soldiers had been routinely invading their village searching for gold as well as looking the other way while miners robbed the Pemons of the minerals on their homelands.

They demanded attention from the government.

In the meantime, all flights into the jungle were grounded. We waited and watched the news, simultaneously cheering on the Pemons and hoping for a settlement so we could fly south. Tensions were high and every roadside arepa stand was discussing military checkpoints, President Chavez's health, and the political unrest across the country.

Kameron, José's wife, even sent us each an email asking us not to go on, fearing we might get attacked by guerrillas or in trouble with the government.

FINALLY PLANES BEGAN FLYING AGAIN AND WE HEADED TO YUNEK.

Chief Leonardo and his family ran to meet us on the runway. We received warm hugs and laughter as we reunited with all of our Pemon friends. In addition to the solar materials, we again brought art supplies for the children. This time we initiated painting projects on their muted grey school building, adding arching swoops of reds and yellows to the walls. We then suggested putting up portraits of people I had photographed last year on the doors around Yunek. I had brought with me eight printed black-and-white portraits, intending to wheat-paste them in random spots. The villagers were skeptical about the idea, but gradually the doors opened or closed, as it were, and we placed the images around the village.

The kids thought it was hilarious to see the faces on doors; the adults laughed in embarrassment, but seemed pleased.

After spending one night in base camp,

we hurried back to the wall on Acopan Tepui, preparing to fully commit to the summit in the morning. Pat and I sat on a boulder in the savannah, watching the sun set as the wind blew a song of welcome in the grass. The trees clapped their leaves in harmony, and we felt surrounded by beauty. I stretched my legs and scrambled around the neighboring rocks in a dance. My body was itching to be up there. We had come a long way for this second chance, and I wanted to be ready.

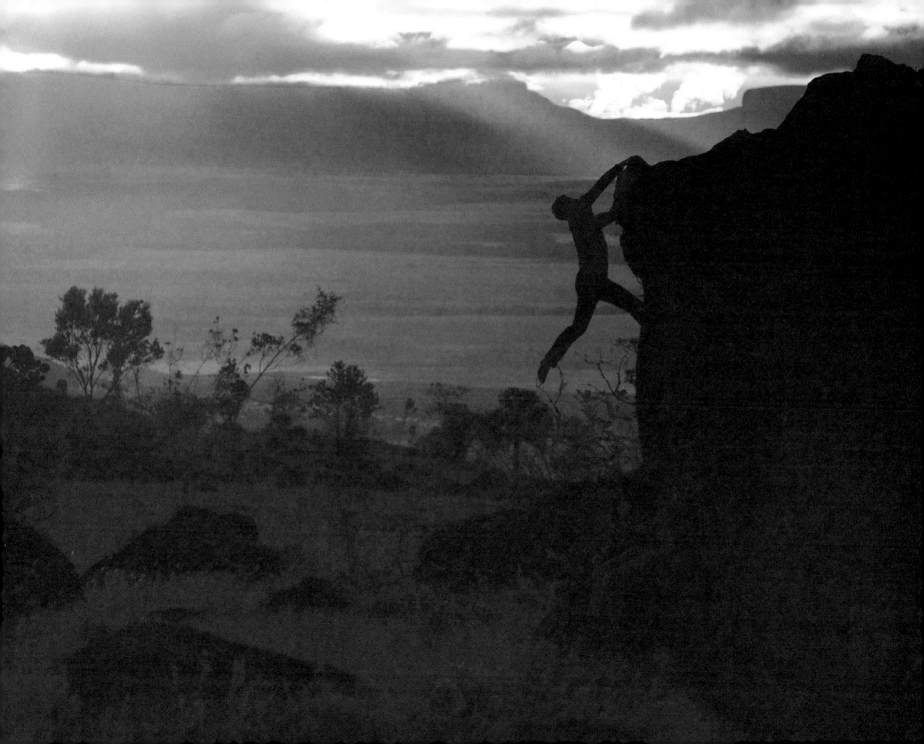

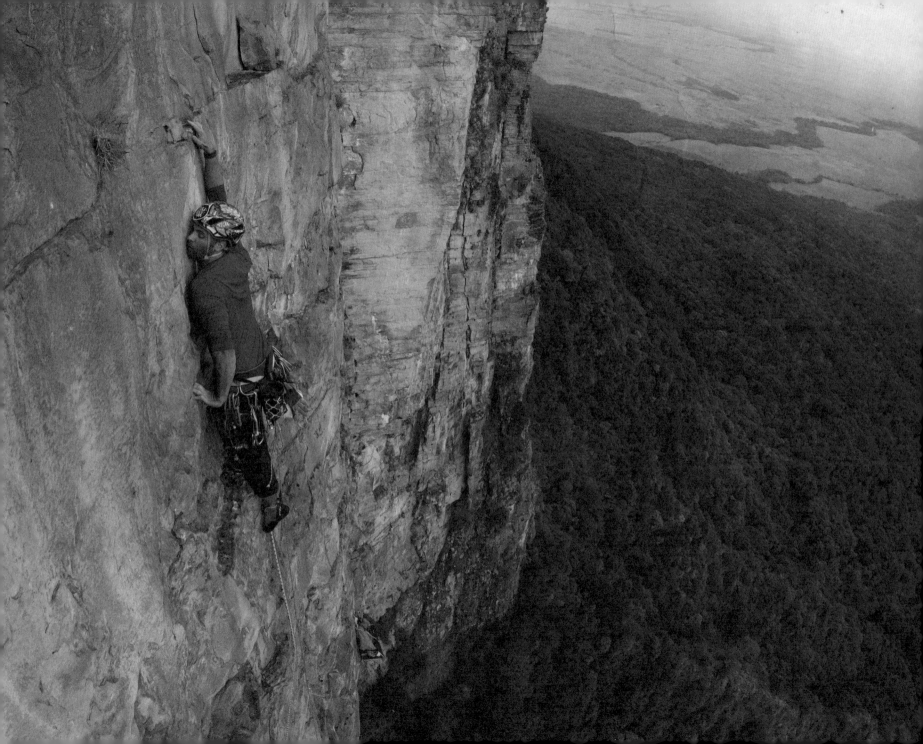

Attached to our skinny rope, 1,000 feet up and miles away from Yunek, my breath was measured and focused as I tried to find the path where Acopan was allowing us passage. The wind blew across my brow like a whispered secret and kept me company, as I could no longer see or hear Pat far beneath me. I angled sideways across the rock, aiming for a crack in a roof 130 feet away. The rock was gorgeous and immaculate, with swirling instances of red and ochre alternating in texture from glass to concrete. The movement felt fluid despite the occasional 50-pound or heavier boulder falling away under my feet or releasing from my hands. Because the wall was so steep, any rock that detached would free-fall hundreds of feet into the waterfall beneath us and splash into the pool at the base.

With another rope-length behind us, we inched our way closer to the final roofs and the glowing summit. Over four nights on the wall, we had steadily progressed upward, with only a 200-foot feature left to climb. We converged on a small ledge for the final push, José arriving last via roughly 1,000 feet of ascending free-hanging ropes.

His entire body was worked and ready for the summit, but he still carried his infectious smile.

"I'm tired, dooodz."

His breathing was audible.

"But the summit looks pimps."

Pat took off on the lead, delicately threading the rope through two immense features of detached rock shaped like guillotines that threatened to wipe us all out if he approached them in the wrong way. Capital Q dangled behind him with his camera rolling, while José and I hunkered together, silently watching Pat's masterful use of gear to redirect the rope and push through to the final feature, a sharp black corner on the skyline.

Beyond this he disappeared, as the rope moved ever upward for a quiet hour. Eventually the radio crackled with an "off belay, boys, get up here. It's a false summit, and we still have far to go." I followed quickly, admiring Pat's work on this section, as it grew steeper and steeper with fewer opportunities for protection. Here was the work of a master.

The features shifted from sheer blank wall to wild organic shapes, as if we were walking through a delicate mounted pottery exhibit. Frozen shrieks of rock twisted and turned skyward as if they were once alive. Over the next two hours we worked through the final headwall to the summit, weaving in and out of prickly cactus and steep, brittle rock. Finding little gear to place, we would run it out in sections where a 100-foot fall was the standard threat at all times.

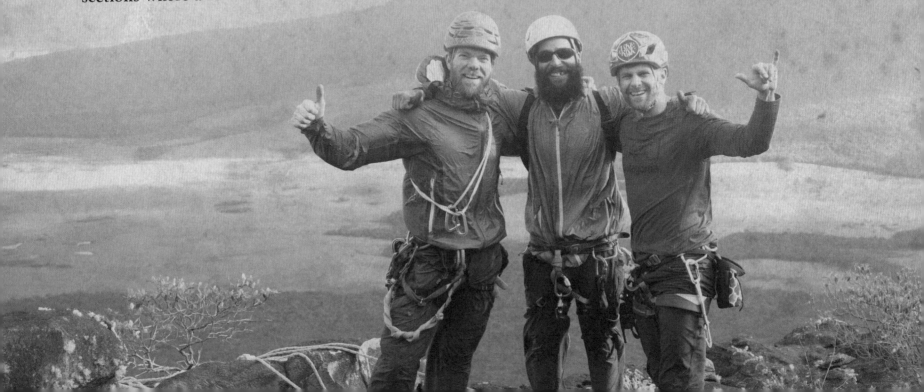

"Off belay!"
"Waaatch me!"
"ROCK!"
"LINES FIXED!"

And then, unceremoniously, there was nothing left to climb and the sky surrounded us. We perched on top of Acopan as an immense wind ripped across the savannah.

① Purgatory
② Libecki / Dempster
③ Pizza, chocolate y cerveza
④ Mondo perdido
⑤ Mystery
⑥ Checo 5
⑦ Lost in Venezuela
⑧ La pa, Yuca, y cobhize
⑨ 10 POUNDS
⑩ El Ego De Ogre
⑪ Jardineros de Grandes Paredes
⑫

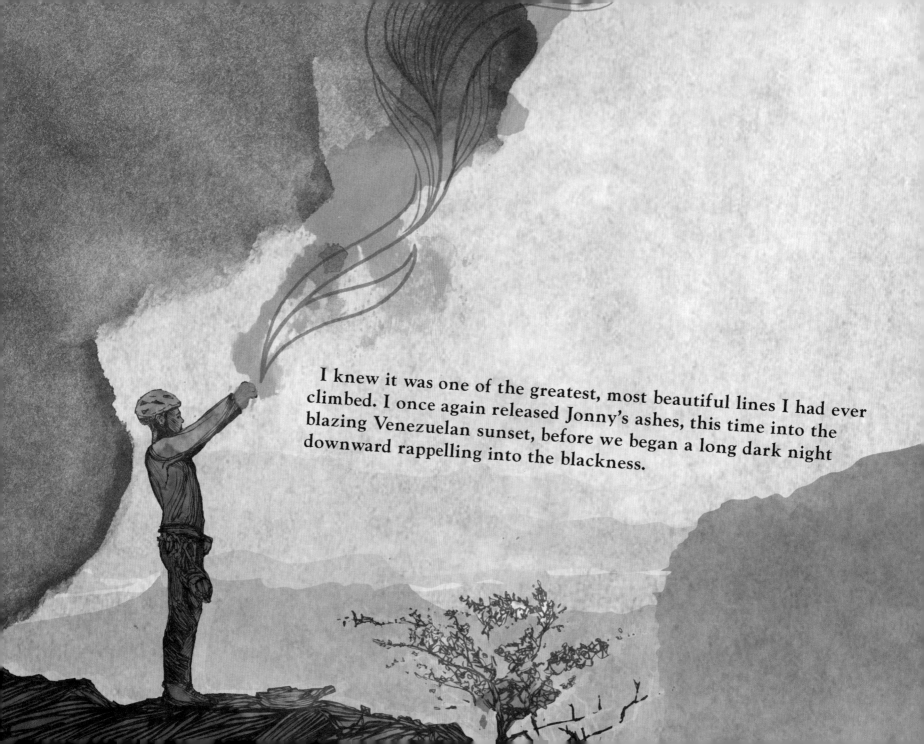

I knew it was one of the greatest, most beautiful lines I had ever climbed. I once again released Jonny's ashes, this time into the blazing Venezuelan sunset, before we began a long dark night downward rappelling into the blackness.

Many of these rappels were so steep that we had to "down-lead" the pitch, kicking out into the dark and back into the wall to place gear, until we eventually reached the end of our rope and returned to well-plotted rappel stances.

The darkness swallowed us like a python, and communication on the radios was reduced to the basics.

"off rappel!"

"Aaghh!! I'm hanging in Space! Pull me in! pull me in!!"

"I made it to the portaledge. Where's the rum?"

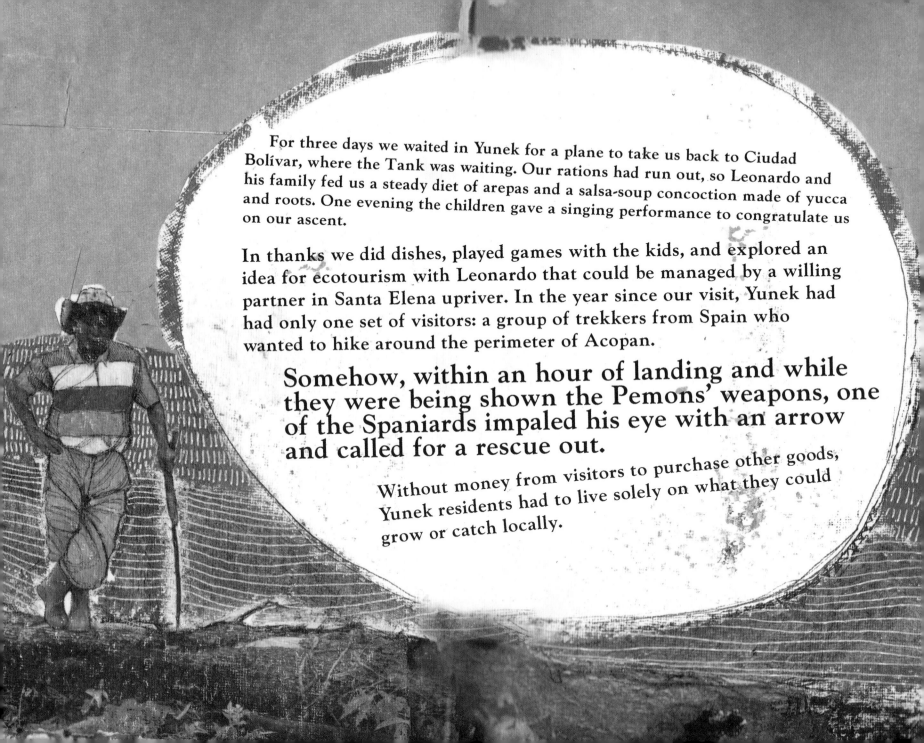

For three days we waited in Yunek for a plane to take us back to Ciudad Bolívar, where the Tank was waiting. Our rations had run out, so Leonardo and his family fed us a steady diet of arepas and a salsa-soup concoction made of yucca and roots. One evening the children gave a singing performance to congratulate us on our ascent.

In thanks we did dishes, played games with the kids, and explored an idea for ecotourism with Leonardo that could be managed by a willing partner in Santa Elena upriver. In the year since our visit, Yunek had had only one set of visitors: a group of trekkers from Spain who wanted to hike around the perimeter of Acopan.

Somehow, within an hour of landing and while they were being shown the Pemons' weapons, one of the Spaniards impaled his eye with an arrow and called for a rescue out.

Without money from visitors to purchase other goods, Yunek residents had to live solely on what they could grow or catch locally.

We asked Leonardo about a large plane we had seen land in the valley when we were high on the wall.

"That was a government plane, delivering tools and pumps for us to mine for gold on our own land. We don't know what else to do."

A muted disappointment settled over our group.
Leonardo shared our distaste for this reality but,
at the end of the day, he wanted what was best for his tribe.

AS A FATHER, I COULD RELATE.

The plane finally arrived, and we made another epic journey back to Caracas in the Tank. It broke down, and I took a cab to the airport. I made it home just in time for a dad's day event at Zion's kindergarten class.

Chief Leonardo
Yunek

ACOPAN

SOUTH FACE PITCHES

FEB
2012/13
JER COLLINS
PAT GOODMAN
JAMES Q MARTIN
JOSÉ RICARDO MIRANDA

In Gold Blood 5.13d or 12c A1

11+ ① Step out of the jungle to a pedestal ledge to one of three bolts protecting a wet section (permanently) then follow perfect white stone past __ bolts with occasional gear placements

13b ② Boulder problem right of the anchors, then begin trending left through increasing difficulties with numerous mini cruxes. __ Bolts with some gear. Belay beneath dihedral.

12b ③ Start up dihedral, then trend right to a crack on an arete. When that terminates follow a blank corner that eventually begins traversing right. Very technical __ bolts, some gear.

12c ④ Begin trending left to the "sailboat flake", past the "water ripple mantle", then right up a layback to a stance. Above is 15 meters of technical crimps and dynamic moves. __ Bolts, some gear.

11a ⑤ "The Sidewinder" Along winding traverse that brings you to the cupped hand roof. Follow the path of least resistance, up and over, up and over on some amazing climbing. to a perch beneath the roof. 2 Bolts Triples to #1 camalot #2. 5 handy

11a ⑥ "THE BEST PITCH IN THE UNIVERSE" Find the weakness in the Roof above, then pull through on increasingly large and deep "crack-rails", leading you left out numerous bulges. Pull the Roof on the far right, then up a juggy dihedral. Doubles to .75

11+ ⑦ Move belay left on "CHICKEN EXIT" ledge beneath a white dihedral. Up loose blocks to this, then pull a boulder problem crux, exiting onto some rotten but easy climbing. Small rack. Belay @ the green bench. (2 Bolts) 50'

10 ⑧ Avoid the immense loose flakes above by angling left, eventually popping out on the south face on an arete covered with amazing sculptured holds. Stop at a large shelf. 30M

10 ⑨ "The jungle pitch" continue up sculptured jugs, eventually trending right until above roofs on east face. Pull up to ledge with Rap station.

11+ ⑩ Walk across ledge left to face on an arete with a bolt (crux). An amazing finishing pitch up a spectacular arete with large holds and good gear

5th ⑪ Scramble left or right up a chimney to the summit ridge

CHAPTER 6:

Latitude to Roam

"Nobody wants to be here and nobody wants to leave."

- Cormac McCarthy,
The Road

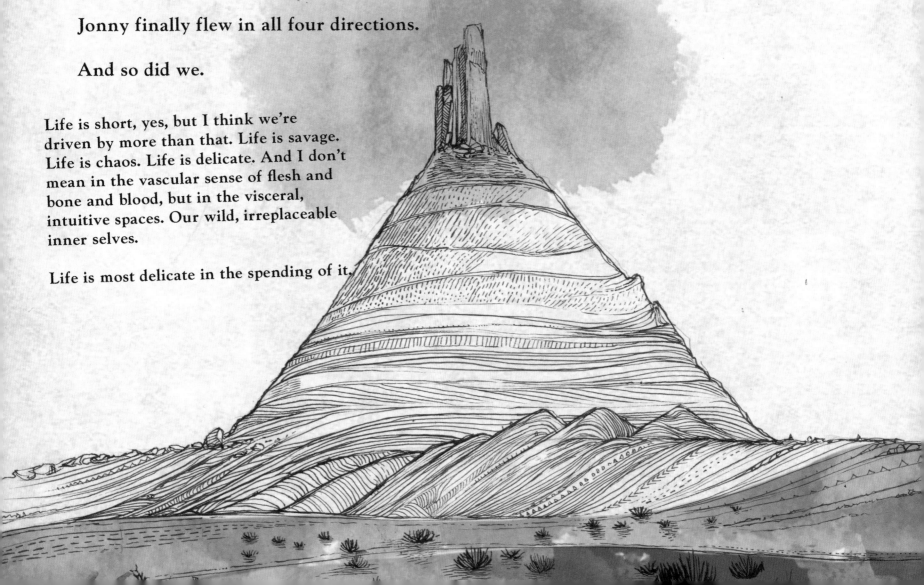

It didn't all turn out the way I thought it might, my journey in four directions.
Adventures never do, and that doesn't bother me—too much. We all come back different but the same, and hopefully better for our efforts. And you can't see that as a failure.

We went back to Venezuela. We made art with our friends. We celebrated their lives and their stories. We hiked back through the jungle, and up the wall past our previous effort.

Jonny finally flew in all four directions.

And so did we.

Life is short, yes, but I think we're driven by more than that. Life is savage. Life is chaos. Life is delicate. And I don't mean in the vascular sense of flesh and bone and blood, but in the visceral, intuitive spaces. Our wild, irreplaceable inner selves.

Life is most delicate in the spending of it.

I have plenty of adventures awaiting me at home. Home is an enigma for me. I feel comfortable, valuable, and loved, but ever itching to leave to ... wherever, whatever is next, I guess. Call it stir-craziness, summit fever, or nomadic impulse—I feel the need to be in perpetual motion.

My passport for the last decade has had a good run. Weathered and exhausted, it sits in the nightstand drawer next to my bed. The new one sits on top of it, with crisp edges and clean sheets awaiting their next stamps of approval. From time to time I will pull out the old one and thumb through to reminisce. Behind every stamp is a worthy memory.

And shouldn't that be the point?

In the end, the experiences, friendships, and stories collected along the way are what I hold as success, not the arbitrary and short-lived moves done on rocks or being first at something.

But firsts matter too. First climb. First job. First love. First kiss. First child.

toad

turtle

This toad
Peed on my dads hand.

This turtle
didnt run away.

We are born to explore and pursue our own firsts, however we define them, whether that means the outer limits of the known physical map, the inner chasms of our imagination, or our own identity.

Simon Garfield, author of On the Map, says that maps

"REFLECT OUR BEST AND WORST ATTRIBUTES- DISCOVERY AND CURIOSITY, CONFLICT AND DESTRUCTION - AND THEY CHART OUR TRANSITIONS OF POWER."

I went in four directions because I had lost my bearings, and my family gave me the "latitude to roam."

I'd like to think I found my bearings. I grew into my story, as my story grew into me. And then I came home. Here is my refuge. My partner. My children.

I am sorry to report I received no higher knowledge at the summit of those mountains. No cloth-diapered yogi squatting on a hemp carpet with nuggets of wisdom awaited my curiosity. The glowing blue ethereal hand of God did not give me instructions engraved on stone.

There was only rock, water, air, and the way back down.

There was, however, perspective—I promise you that. The only way to see from the summit is to go there.

The
monarch
flew
Past
us!

And in between the summits,
we live and gain strength.

In between the summits, life happens.

Real life, like soccer games and work
and anniversaries and births and deaths and
dance parties.

I love dance parties.

EPILOGUE

WEST

Mikey put up another, much harder route on Middle Cathedral just to the left of ours. Maybe his hardest slab route yet. He still lives half the year in Patagonia, but spends the other half in a real live house. Jonny Copp's dad, John, has died of prostate cancer; his mother, Phyllis, and sister, Aimee, continue to be part of my family.

Want to do good for Yosemite? Check out the Yosemite facelift: yosemiteclimbing.org

EAST

The new park in Keketuohai is now open, and it not only allows climbing on its beautiful formations, it celebrates it. Since our trip, Mark Jenkins has been to the summit of Mount Everest and visited 13 more countries (and been arrested in none of them). The Caldwells and Riches have each had one child.

Want to do good for biodiversity in Xinjiang province? Check out
The Nature Conservancy's China Conservation Blueprint at nature.org

NORTH

Pat returned to the Vampires again to climb a wall we saw from the summit of the Phoenix. He is working on a guidebook to the area with the pilot Warren LaFave. Jeff Achey has achieved his black belt in soo bahk do. James Q Martin became the producer who helped turn my story into a film.

Want to do good for Canadian wildlife? Check out the Canadian Wildlife Federation at cwf-fcf.org

SOUTH

Six months after leaving Venezuela for the second time, I received a call from José Miranda. Five men with semiautomatic weapons had invaded his home, held him and his family to the ground under their boots, and stolen everything of worth, including the innocence of his children. The men left, and shortly thereafter, so did the Mirandas. They moved to Colorado in the United States to start over. Leonardo, the chieftain of Yunek, gave up on finding gold after six months and asked the government to retrieve the pumps and mining tools. At his request, we're working on finding a way to help his village develop tourism.

Want to do good for indigenous tribes? Check out survivalinternational.org and causecentric.org

ACKNOWLEDGEMENTS

Between the journeys themselves, the film, and now this book, I was blessed beyond belief with support from all around the globe, and for that I am eternally grateful. Here I'd like to acknowledge supporters, sponsors, and crew that made it all happen.

My editor—Kate Rogers. You are insane for believing in this project. And that's why it got done. Thank you to EVERYONE at Mountaineers Books for support, ideas, and vision.

My team at Meridian Line. I told you I needed to go hide in a hole to finish this and you let me. Thank you. The future is bright. My Kickstarter backers. You believed in this project and put your wallet where your mouth is. Keep supporting OTHER projects by other dreamers. You'll be better off for it.

My climbing partners—Jonny Copp, Mikey Schaefer, Dana Drummond, Mark Jenkins, Tommy Caldwell, Hayden Kennedy, Corey Rich, Pat Goodman, José Miranda, Jeff Achey, and Capital Q Martin. You pretty much had no idea where this project was headed and to be honest, neither did I. Thank you for letting me figure it out. A special thank-you to John Branagan for keeping us off the ground.

My sponsors—Keen, Bluewater Ropes, Evolv Sports, Skratch Labs, Patagonia, CLIFbar, DeLorme, and GoalZero. Behind each of these brands is a PERSON who believes in the ART OF ASCENT. Thank you, thank you, thank you.

To the Jonny Copp Foundation and the American Alpine Club—THANK you for support and BELIEF!

To Kevin and Kristen Howdeshell for everything. To Q and Isaiah and Timmy for pushing hard on the film. To Ric and Jen Serena and Jason Fitzpatrick from The Muir Project for hours of input. To Tim "GO BABY" Keel. To Jeff "Make it about the art" Johnson. To Jay "Are you done yet?" Peery. To Yvon "You just blew my mind" Chouinard. To David "DO IT!" Munk. To John "Largo" Long for help in Venezuela. To the Miranda family: I love you all tremendously. To Marcos the pilot who rescued us in Yunek. To Warren LaFave for rescuing us in the Vampires. To Jack in China who made the bureaucracy less crazy. To Pat Warren and Jarod Sickler in Yosemite. To Joni Cooper. To David Huffman. To Steven Bumgardner, Sender Films, Dominic Gil, Carl Zoch, and Andy "the cat whisperer" Michael. To Gregory Kolsto. To Phyllis and Aimee Copp. Thanks for the patience, support, vision, tears, and cheers. You are family. To my in-laws, Allen and Connie. You literally made this happen with all the support and babysitting. If you have read this far you are just looking for your name. To my family. To my love. To Zion and Sela. Thank you. Whether you go from east to west, north to south, or ground to summit, don't miss the path from heart to head. It's between these two destinations we find our voice.

BE DAREFUL OUT THERE

Now... Where are you drawn? Color on, draw on, scheme on, and dream on the map to the right and share it with me.

Jeremy Collins's art has been featured in more than 150 climbing magazines including the cover of *National Geographic* magazine and in numerous books and mainstream media.

He has helped raise thousands of dollars via his art for various causes and nonprofits including Rios Libres, American Rivers, pediatric brain cancer research through the Kyrie Foundation, The Access Fund, American Alpine Club, Habitat For Humanity, Causecentric, and water.org. He currently volunteers as a section chair for the American Alpine Club, Cliff Drive Corridor Management Committee, and Rios Libres.

He has also donated his time in Venezuela, where he and his team delivered solar power to a small village. Jeremy later returned to that village to lead creative art projects with the children.

His films explore the intersection of adventure and "real" life. His film/stage production "The Wolf & the Medallion" won the Banff Centre's Creative Excellence Award and 5 Point Film Festival's Best of the Fest. His film, DRAWN, made from this book, won Best Script at the Mendi Film Festival in Bilbao, Spain, as well as the Award for the Transmission of Mountaineering Values.

On the rock Jeremy has pioneered more than 300 new routes in the United States. He has climbed extensively internationally with notable first ascents in Argentina, Venezuela, Canada, and China.

Jeremy and his wife, Tricia, live in Kansas City, Missouri, in the USA with their two children, Zion Ray and Sela Muir. He is the founder of the lifestyle brand Meridian Line.

Learn more and see DRAWN the film at Jercollins.com

Meridian Line can found at themeridianline.com

MOUNTAINEERS BOOKS

SKIPSTONE BRAIDED RIVER

recreation · lifestyle · conservation

MOUNTAINEERS BOOKS, including its two imprints, Skipstone and Braided River, is a leading publisher of quality outdoor recreation, sustainability, and conservation titles. As a 501(c)(3) nonprofit, we are committed to supporting the environmental and educational goals of our organization by providing expert information on human-powered adventure, sustainable practices at home and on the trail, and preservation of wilderness.

Our publications are made possible through the generosity of donors, and through sales of more than 600 titles on outdoor recreation, sustainable lifestyle, and conservation. To donate, purchase books, or learn more, visit us online:

MOUNTAINEERS BOOKS

1001 SW Klickitat Way, Suite 201 • Seattle, WA 98134
800-553-4453 • mbooks@mountaineersbooks.org • www.mountaineersbooks.org

OTHER MOUNTAINEERS BOOKS TITLES YOU MIGHT ENJOY!

12-

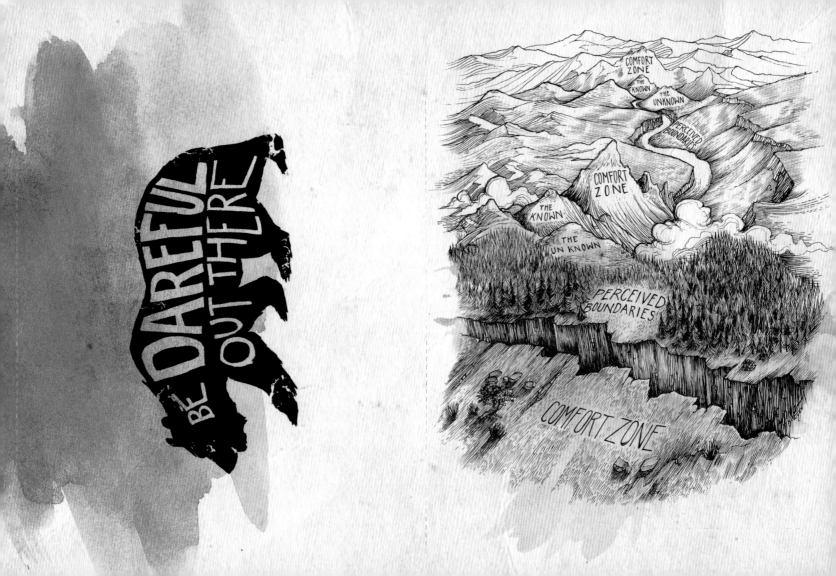